IMAGES
of America

TAMPA'S
CARROLLWOOD

ON THE COVER: Pictured on May 23, 1927, a family enjoys a picnic near the shore of Lake Magdalene on what appears to be a breezy day. In the 1920s and 1930s, this would have been a common sight along the lakesides of what is now known as the Carrollwood area. (Courtesy of Tampa-Hillsborough County Public Library.)

IMAGES
of America

TAMPA'S
CARROLLWOOD

Joshua McMorrow-Hernandez
with a foreword by Lois Abbott Yost

ARCADIA
PUBLISHING

Published by Arcadia Publishing
Charleston, South Carolina

Printed in the United States of America

Library of Congress Control Number: 2013936147

For all general information, please contact Arcadia Publishing:
Telephone 843-853-2070
Fax 843-853-0044
E-mail sales@arcadiapublishing.com
For customer service and orders:
Toll-Free 1-888-313-2665

Visit us on the Internet at www.arcadiapublishing.com

*In memory of my mom, Susie; and to my dad, Rudy; my sister, Kelly;
my beloved, Katya; and all my loved ones and friends who supported me
along the way.*

CONTENTS

FOREWORD

I first learned about Carrollwood through my dad's stories: how he was sitting on the porch of the United Brethren Church parsonage when the 1921 hurricane blew the frame church off its foundation.

As a child living in Tampa, I spent many summer evenings with family and friends swimming and picnicking at the public Lake Carroll and Lake Ellen beaches.

My husband, Jim, and I and our children, Richard and Nancy, moved into our newly built home on Lake Lipsey in 1963, about the time Carrollwood Elementary School was being built. Fifty years ago, we had to travel at least three miles to buy a loaf of bread. Thirty or forty peacocks regularly gathered on our patio for their daily bread. Children were on their horses exploring the wilderness around us. Our pony and sulky traveled up and down the almost deserted roads. Dale Mabry, which was built between MacDill and Drew Field, had recently been extended north of Hillsborough Avenue. Strip malls have been built and businesses came and went. We have seen traditions like the Fourth of July and Pumpkin Parades develop.

Through our affiliation with Lake Magdalene United Methodist Church, it has been a privilege for my family and me to know personally most of the pioneers of this area and to listen to their tales of life before my time. A walk through Lake Carroll Cemetery helps to recall names, faces, and stories.

Over the past few decades, history has been my top interest, including working on family genealogy and participating in leadership roles in local, state, southeastern, and national United Methodist Church archives, history commissions, and historical societies.

It has been exciting to meet young Joshua McMorrow-Hernandez, raised in the area north of Tampa, who has explored the history of every aspect of his neighborhood and has documented his findings in such an interesting way.

—Lois Abbott Yost

ACKNOWLEDGMENTS

I want to thank so many individuals and organizations for providing images, stories, and information for this book. I must first thank Lois Abbott Yost, a longtime Carrollwood resident I met while compiling this book and who has been absolutely essential in making it become a reality. She has shared many memories and stories and put me in contact with numerous individuals, including the community's pioneer families, all of whom lent me their time, stories, information, and photographs. Yost is a historian and longtime member of Lake Magdalene United Methodist Church (LMUMC), where I have met many fine people who have helped me in countless ways, including sharing with me their time, stories, and archival photographs.

There have been many others who have helped me throughout the compilation of this book, including Phil Alessi Sr.; Bob Baggett Photography; the Bearss family; Jennifer Bush and the staff at Publix; James Cass and the staff at The Carrollwood Players; John Cinchett; Greg Colangelo and the staff at the Hillsborough County Planning Commission; the staff at Corbett Preparatory School of IDS; Roxanne Clapp; Deacon John Alvarez and the staff at St. Paul Catholic Church; the staff at Cecile Essrig Elementary School; Dan Fucarino; Delia Gadson-Yarbrough and the staff at Lake Magdalene Elementary School; Paul Handy; Beverly Harris and the staff at Grace Lutheran Church; Andy Huse and the staff at the University of South Florida (USF) Library Special & Digital Collections Department; Ron Kolwak; David Parsons; Susie La Roe; Tom Levin; Jan McMahon; Maria Patterson; Stacey Roller and the staff at Carrollwood Elementary School; and Gary Wishnatzki.

I appreciate the help provided by countless others who have encouraged me throughout this project and have shared with me the necessary resources and contacts to complete this book. Thank you, one and all.

INTRODUCTION

Driving down busy North Dale Mabry Highway in Carrollwood, it may be hard for some motorists to realize that before the sprawl of suburbia was built in the 1960s, they were more likely to stumble upon a citrus grove, country cottage, or cattle ranch than a big-box store, shopping mall, or housing development. Of course, times change and so, too, do communities.

Before the arrival of the Carrollwood subdivision (now commonly referred to as Original Carrollwood) around Lake Carroll in 1959, most areas of northwest Hillsborough County were very sparsely populated. In fact, during the first half of the 20th century, many of the homes around Lake Carroll and the other lakes in the area were occupied only on the weekends by residents who lived closer to downtown Tampa and wanted to escape the hustle and bustle of city life for a couple days. Meanwhile, Horse Pond Beach (which was on what we now refer to as Lake Carroll), Lake Ellen Beach, and many other nearby lakeside spots were open to the public and attracted Tampans who wanted to swim in the area's clean waters or picnic along the scenic shores.

However, there were also year-round residents before the 1960s in the area now referred to as Carrollwood, a name that is said to mean "the land of lovely woods and water." And, by the way, before going much further in this book, it is important to explain just what is meant when referring to "Carrollwood" here. While officially Carrollwood is the 925-home community developed around Lake Carroll beginning in 1959, Carrollwood, as referred to in this book, includes neighborhoods beyond the subdivision now commonly referred to as Original Carrollwood.

While everybody has an opinion as to where Carrollwood's boundaries lie exactly, for the purposes of this book, most of the photographs will focus on the neighborhoods surrounding Lake Carroll, Lake Magdalene, White Trout Lake, and Lake Ellen. Please note there are also several relevant photographs in this book that were taken from just beyond those immediate areas to help tell a more complete story about the community, now popularly called the Greater Carrollwood area, and its associated neighborhoods.

By the 1880s, there was already a sparsely populated community north of Lake Carroll and around Lake Magdalene. In fact, there was a post office built in 1888 near modern-day Fletcher Avenue in the vicinity of present-day Lake Magdalene United Methodist Church. Unfortunately, there is little existing information about this post office, other than that the mail processed there was postmarked "Magdalene, Florida" and George A. Morris served as postmaster.

The neighborhood would change forever in 1894. After enjoying a visit to the area around Lake Magdalene in February of that year, Rev. Issac Ward Bearss would arrange for a group of 11 people to caravan by wagon train from Trenton, Missouri, to Lake Magdalene. The group, which left on October 4, 1894, arrived December 20 of that year after a 1,300-mile journey, during which every Sunday they would attend services at nearby churches along the way or hold services in camp if the nearest church was too far.

Reverend Bearss and his son William Otterbein "Ott" would arrive before the wagon train; Amanda Marie Jeffries Bearss (wife of Reverend Bearss) and their three younger children would

come to Lake Magdalene in autumn 1895. Persevering through one of the worst freezes in Florida only a few days after their 1894 arrival and a second bad freeze the following February, Reverend Bearss and his group began the first mission of the Church of the United Brethren in Christ by the end of their first winter near Lake Magdalene. The church, which was where the majority of community events occurred during its first decades, would continue to grow over the years.

The largely rural community was a hotbed for citrus growth, though other forms of farming also flourished, including raising livestock. For the most part, the areas around Lakes Carroll and Magdalene, as well as Lake Ellen and White Trout Lake, would remain populated by citrus farms, lakeside vacation cottages, and a few homes.

Just to the east of Lake Carroll, significant development would first arrive in 1926 when B.L. Hamner would build Forest Hills Golf and Country Club, with the golf course originally surrounded by about 10 homes. A handful of blocks to the west, on the southeast shores of Lake Carroll, another small development of roughly a dozen homes would be constructed along Circle Drive (now Carroll Place, west of Park Street) over the following few years.

In 1957, the future of what would become known as Carrollwood started taking shape when a young man named Matt Jetton began buying acreage around Lake Carroll. It is interesting to note that Jetton was the grandson of Matthew Jetton, who ran a lumber mill near Kennedy Boulevard and Rome Avenue and later helped develop Hyde Park in South Tampa; Jetton Street is an east-west road that was named in Matthew Jetton's honor and runs through much of the Interbay Peninsula. The younger Jetton would buy more than 300 acres around the southern, western, and northern shores of Lake Carroll, including 200 acres of J.M. Ingram Fruit Corporation orange groves as well as about a dozen smaller properties.

In 1959, Jetton started selling homes in Carrollwood under the banner of Sunstate Builders Inc., which was the real estate development firm he operated. Lots generally varied from 8,200 to 25,000 square feet and cost $2,750 to $16,000 during the early 1960s; most homes were custom built and ranged in price from $16,000 to $60,000 during that same time. While many people initially wondered who would buy such expensive homes "out in the sticks," Jetton knew exactly what he was doing. His development benefitted mainly from its picturesque setting on Lake Carroll, which attracted many Tampans looking for respite from congested city life. At the same time, the University of South Florida was being constructed only a few miles to the east, with the first classes being offered in the fall of 1960. Many of Carrollwood's earliest residents, in fact, belonged to the university's faculty and administration.

There has always been a certain charm to Carrollwood. Maybe it is the tree-lined boulevards, flanked with sidewalks and streetlights. Or perhaps it is the free-roaming peacocks, a vestige of the Ingram family, who introduced the birds to their Lake Carroll orange grove because of their screeching calls, the perfect burglar alarm. It might even be the community's unique street names, such as Nakora, Samara, and Korina, which were names of popular plywood varieties in the 1960s; these were some of the first names to pop into mind of the community's award-winning home designer, Betty O'Neal (then Betty Wild), when she had to hastily name the subdivision's streets for the United States Post Office Department. In fact, she even helped choose the community's name, in itself unique at a time when Sunstate's own advertising agency pushed for a two-word community name that ended with "Estates" or "Park" (a popular convention for naming communities being built at the time) and one without as many double letters.

Carrollwood caught the attention not only of local residents looking for a safe, beautiful neighborhood to call home but also the national housing industry. Carrollwood would soon earn such acclaim as US Subdivision of the Year by the National Association of Home Builders in 1961 and the following year won the Best Homes for Families with Children Award from *Parents* magazine. Carrollwood's popularity only continued to grow and, by the end of the decade, the entire community was virtually built out. Jetton, however, was not finished building.

By the early 1970s, Jetton had his eyes on nearly 2,000 acres of land just west and north of his first Carrollwood development. After acquiring land from more than two dozen different owners, Jetton began developing his next suburban masterpiece: Carrollwood Village. Built around a 27-hole

golf course, Carrollwood Village would become a three-phase project consisting of condominiums and single-family, mainly executive-style homes. Some of the earliest condominiums sold for around $23,500, while the base price for custom homes was approximately $60,000. Carrollwood Village continued growing into the 1980s as it meandered north toward Ehrlich Road and as far west as Lynn Turner Road.

Throughout the 1970s and 1980s, other builders got in on the action and would also capitalize on the popularity of the Carrollwood name. By the end of the 1980s, the name Carrollwood would be associated with developments north of Ehrlich Road and Bearss Avenue (Carrollwood Springs, for example) and west of Lynn Turner Road (Carrollwood Meadows); meanwhile, the name would also spring up in real estate listings and on the occasional business sign farther south than Waters Avenue and as far east as Interstate 275.

In the early 1980s, the Carrollwood Civic Association formed a committee to study the concept of incorporating Carrollwood as a city, an idea largely born as a response to increasing taxes for unincorporated county services that many homeowners in the Greater Carrollwood area felt they were not receiving. The city of Carrollwood would have potentially incorporated an enormous swath of northwest Hillsborough County, including Original Carrollwood and any surrounding, unincorporated neighborhoods that wanted to join. The initiative would eventually fail. As the decade of the 1980s wore on, developers of both residential and commercial properties would buy up most of the remaining land along North Dale Mabry Highway from Busch Boulevard up to Bearss Avenue and beyond.

By the start of the 1990s, the Carrollwood area had been nearly built out, and large-scale development projects would shift to the eastern part of Hillsborough County, in places like New Tampa and Brandon. However, Carrollwood would continue to draw new residents with infill development and apartment construction. The community continues to be a favorite place for young professionals, families, retirees, and others who are looking for existing homes in mature, established communities close to the heart of Tampa.

The Carrollwood area is a far different place now than this region of Hillsborough County was at the start of the 20th century. While the cattle, most of the orange groves, and virtually all of the early structures are now gone, traces of the past remain, such as Hamner Fire Tower, Bearss Groves farmer's market, Babe Zaharias Golf Course, Lake Magdalene United Methodist Church, and Lake Carroll Cemetery. While you have to look hard to find them, there are even still a few homes that predate World War II scattered throughout the area.

The Greater Carrollwood area is a place its residents love to call home. It is a community that people enjoy as much today as when Jetton built his homes there in the 1960s, when Hamner built his exquisite country club nearby in the 1920s, and when Reverend Bearss was called to establish a church there in the 1890s and pulled neighbors together from miles around.

The Carrollwood area has countless picturesque ponds and lakes and homes in a wide variety of styles; it is close to major highways, convenient to the Gulf Coast beaches, and has a plethora of shopping, entertainment, and dining opportunities to satisfy even the most discriminating Carrollwoodians. We hope you enjoy a trip down memory lane as you watch this Tampa community blossom into the Carrollwood we know and love today.

One

BEARSS, STALL, AND OTHER NAMES YOU KNOW

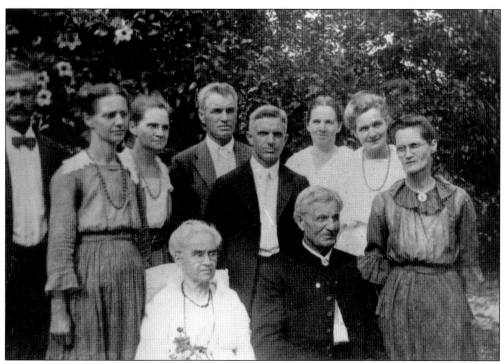

This photograph shows Rev. Issac Ward Bearss seated next to his wife, Amanda Marie Jeffries Bearss, and surrounded by their family on August 28, 1921. Pictured behind the reverend and his wife are, from left to right, Charles Wesley, Clara, Etta, Otterbein, Bishop Markwood (his given name), Anna, Adda, and Mattie. (Courtesy of LMUMC.)

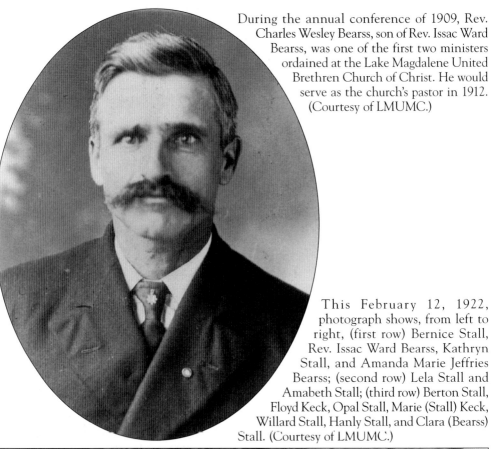

During the annual conference of 1909, Rev. Charles Wesley Bearss, son of Rev. Issac Ward Bearss, was one of the first two ministers ordained at the Lake Magdalene United Brethren Church of Christ. He would serve as the church's pastor in 1912. (Courtesy of LMUMC.)

This February 12, 1922, photograph shows, from left to right, (first row) Bernice Stall, Rev. Issac Ward Bearss, Kathryn Stall, and Amanda Marie Jeffries Bearss; (second row) Lela Stall and Amabeth Stall; (third row) Berton Stall, Floyd Keck, Opal Stall, Marie (Stall) Keck, Willard Stall, Hanly Stall, and Clara (Bearss) Stall. (Courtesy of LMUMC.)

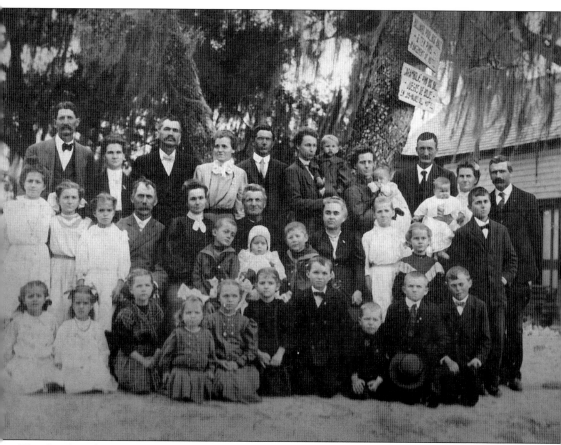

This family gathering was held at Sulphur Springs in winter 1909. Sulphur Springs was an affluent neighborhood and, at five miles to the southeast of Lake Magdalene, was the closest major hub of activity for those living in what today is the Carrollwood area. Pictured, from left to right, are (first row) Ruth Bearss, Florence Bearss, Opal Stall, Adda Mae Bearss, Veda Bearss, Lottie Faye Mendenhall, Ivan Bearss, Arthur Bearss, Willard Stall, and William West; (second row) Esther Bearss, Marie Stall, Mattie Bearss, Lyman West, Mary Adda West with Teddy West, Rev. Isaac Ward Bearss holding Merle West, Isaac West, Amanda Marie Jeffries Bearss, Rosella Mendenhall, Tersa Bearss, and Charles West; (third row) Aaron Mendenhall, Etta Mendenhall, Otterbein Bearss, Ollie Bearss, Markwood Bearss, Lula Bearss holding Harold Bearss, Clara Stall holding Hanly Stall, Berton Stall, Katie Bearss holding Mildred Bearss, and Wess Bearss. (Courtesy of the Harold Bearss family.)

Markwood Bearss and Lula Elizabeth Strickland are on their way to an Independence Day celebration in Tampa on July 4, 1900. They would be married on August 26 of that year. (Courtesy of the Harold Bearss family.)

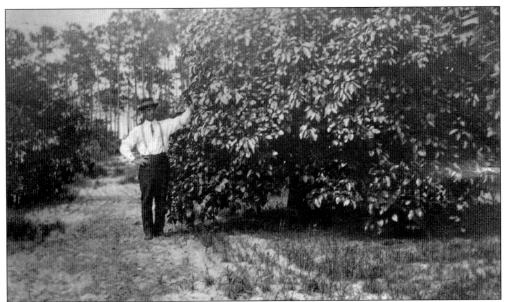

This undated photograph shows Markwood Bearss standing in the family's orange groves. This scene is a perfect illustration of what daily life was like for the Bearss family during their earliest decades in the community. (Courtesy of the Harold Bearss family.)

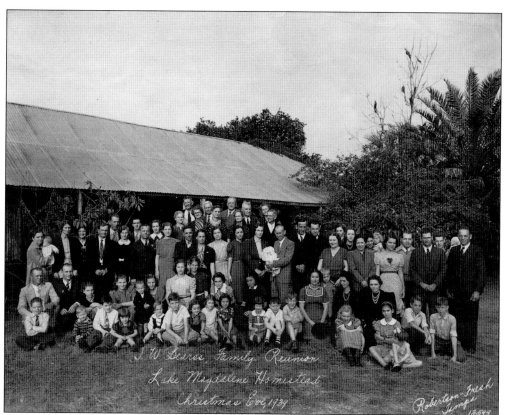

The Rev. Issac Ward Bearss family reunion was held December 24, 1939, at the Bearss family homestead on the northwestern shore of Lake Magdalene. (Courtesy of the Stall family.)

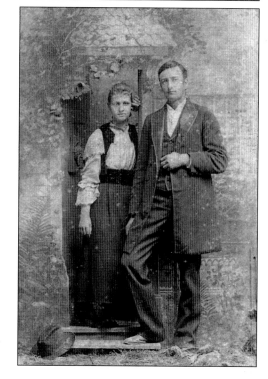

This 1894 portrait shows Berton Stall and Clara Bearss before their marriage on March 31, 1897. At that time, they were still in Trenton, Missouri, but were about to embark on their journey to Florida. Upon arriving in Florida, Berton would purchase land near Lake Ellen and would later donate the land upon which Lake Magdalene United Methodist Church stands today. (Courtesy of the Stall family.)

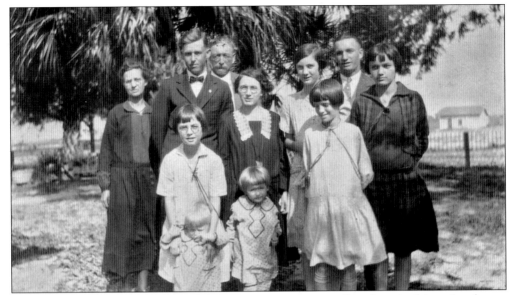

Seen here in this undated photograph are several members of the Stall family. They are, from left to right, (first row) Kathryn and Bernice, (second row) Opal, Marie, Lela, and Amabeth, (third row) Clara, Hanly, Berton, Gladys, and Willard. (Courtesy of the Stall family.)

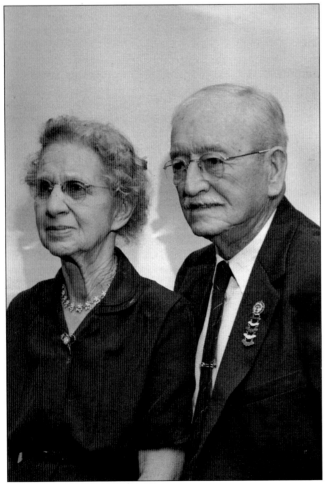

This photograph features Berton and Clara Stall in 1957, which was the year of their 60th wedding anniversary. Berton and Clara, who both came to Florida in the 1894 wagon caravan from Missouri, were influential in the early development of the Lake Magdalene church and the surrounding area. (Courtesy of the Stall family.)

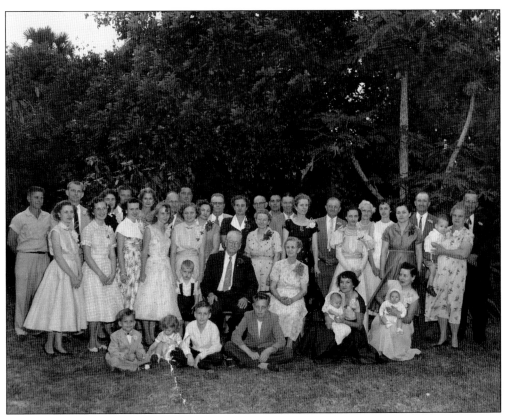

A huge family gathering marked Berton and Clara Stall's 60th wedding anniversary in 1957. Many of the older individuals in this image were residents of the community during its earliest decades and helped establish the neighborhoods around Lake Ellen and Lake Magdalene. (Courtesy of the Stall family.)

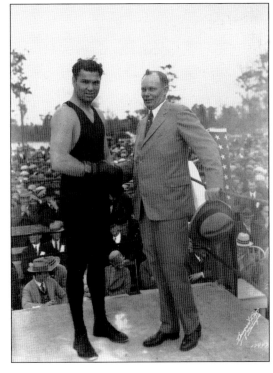

This photograph shows B.L. Hamner shaking the gloved hand of heavyweight boxing champion Jack Dempsey. Hamner, the namesake of a street in the Forest Hills neighborhood and the fire tower that stands at the northwest corner of North Boulevard and West Fletcher Avenue, staged a free boxing event in 1926 to draw interest in what would become his Forest Hills residential development a few blocks east of Lake Carroll. Hamner's slogan was "Sooner or later all the people will take to the hills!" (Courtesy of Tampa-Hillsborough County Public Library.)

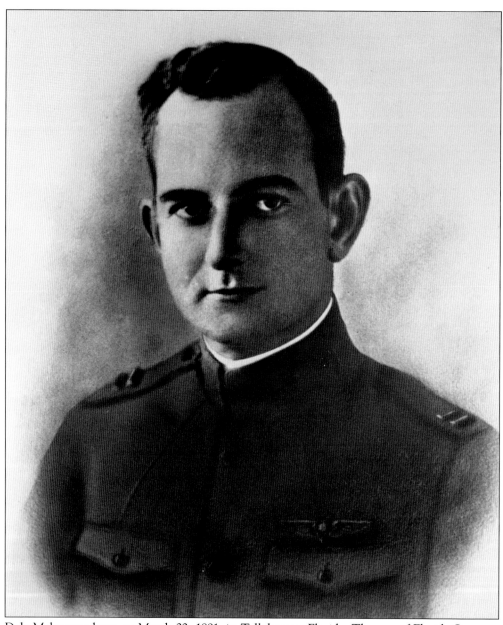

Dale Mabry was born on March 22, 1891, in Tallahassee, Florida. The son of Florida Supreme Court justice and lieutenant governor Milton H. Mabry and Ella Dale Bramlett, he joined the United States Army Air Service and was an aviator during World War I, eventually rising to the rank of captain. He died on February 21, 1922, while piloting the dirigible *Roma*, which was undergoing testing that day in Norfolk, Virginia. The crash killed 34 people and was the worst American aeronautics tragedy at the time. Mabry was buried in Arlington National Cemetery. In 1943, a highway was built linking MacDill Field (today called MacDill Air Force Base) at the southern tip of the Interbay Peninsula with Drew Field Municipal Airport (now the site of Tampa International Airport), and the road was named after Mabry. Incidentally, Tampa also has an elementary school bearing the aviator's name, and in Tallahassee, there is Dale Mabry Municipal Airport. (Courtesy of Florida State Archives.)

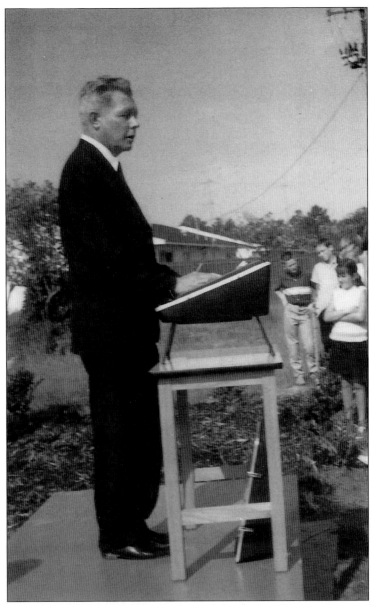

Matt Jetton was only in his mid-30s when he started developing the community that would be called Carrollwood. As the grandson of Matthew Jetton, who helped develop South Tampa's Hyde Park decades earlier, the younger Jetton would carry on the family legacy of building successful communities in Tampa. By the time Matt, president of Sunstate Builders Inc., had started building his first homes in Carrollwood Village in the early 1970s, he had already established a solid reputation in the area as a visionary. But he was more than just a skilled developer. He was also an involved citizen who wanted to leave a positive impact on his community, as he was doing here in this June 1967 photograph when he dedicated newly planted trees near Carrollwood Elementary School. In 1983, when three Hillsborough County commissioners were arrested in a bribery scandal, Jetton was one of three individuals handpicked by then governor Bob Graham to finish the terms of the disgraced officials. "The Father of Carrollwood" passed away February 22, 2013, at the age of 88. (Courtesy of Carrollwood Elementary School.)

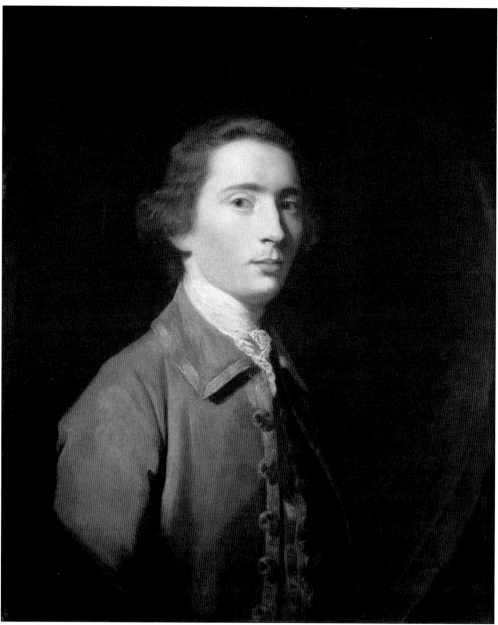

Artist Joshua Reynolds painted this 1763 oil on canvas of Charles Carroll of Carrollton, the namesake of Lake Carroll. One of the first families that lived on the north end of the lake during the 19th century knew Carroll, who signed the Declaration of Independence in 1776 and became the first US senator from Maryland. Carroll, who was the only Catholic to sign the Declaration of Independence, died November 14, 1832. He was the longest-living (95 years) and last surviving of the Founding Fathers. An interesting footnote about Lake Carroll is that it would be known by several names other than Lake Carroll, including Horseshoe Lake, Horseshoe Pond, Horse Pond, Sunset Lake, and Lake Brorein—that last name in honor of William Gebhard Brorein, a prominent Tampa leader who was influential in the city's early development. (Courtesy of the author.)

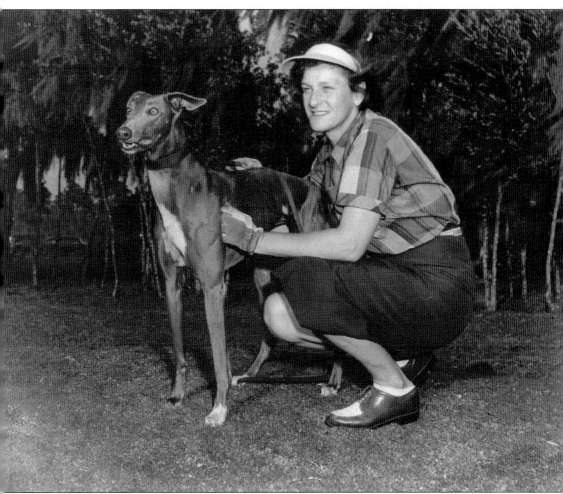

This photograph shows Mildred Ella "Babe" Didrikson Zaharias on December 20, 1951; she purchased the Forest Hills Golf and Country Club in 1949. It was rumored that for a short time she lived in the clubhouse, but she later bought a house nearby. Though a world-renowned golfer, Zaharias was accomplished in many other sports, including diving, bowling, roller-skating, and track and field, the latter for which she won two gold medals and a silver medal in the 1932 Los Angeles Olympics. She even recorded songs for Mercury Records, including "I Felt a Little Teardrop." In 1938, she married professional wrestler George Zaharias, whom she met while playing golf. Despite an illustrious career in athletics, she would unfortunately suffer health issues at a young age. She was diagnosed with colon cancer and passed away on September 27, 1956, at the age of 45. (Courtesy of Tampa-Hillsborough County Public Library.)

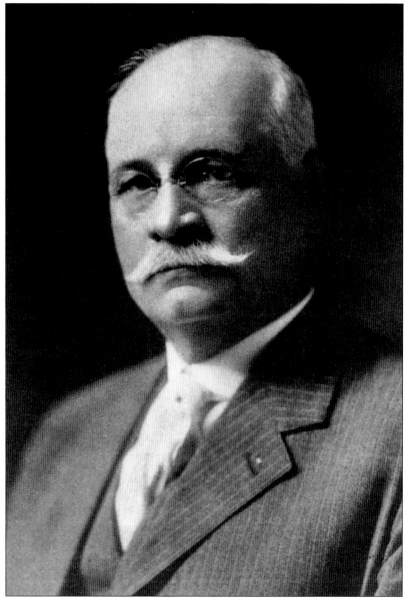

The namesake of an east-west route that connects Dale Mabry Highway to North Florida Avenue in the Greater Carrollwood area, Duncan Fletcher was the longest-serving US senator in Florida history. The Democrat entered office on March 4, 1909, and over his long career, served on numerous government committees, including the Committee on Commerce subcommittee that investigated the *Titanic* disaster and chairmanship of the Senate Banking and Currency Committee, during which he was charged with the task of determining the causes of the Wall Street crash in 1929. Though his career included many political achievements, he also contributed much outside of the political arena. He was a founding member and the first president of the Jacksonville Bar Association and established the First Unitarian Church in Jacksonville, Florida, in 1907. Additionally, he was involved in several affairs relating to Tampa, including his public support of helping build the Gandy Bridge, which became the first roadway to span the bay in 1924. Fletcher died on June 17, 1936. (Courtesy of Florida State Archives.)

Two

LAKE MAGDALENE
CHURCH

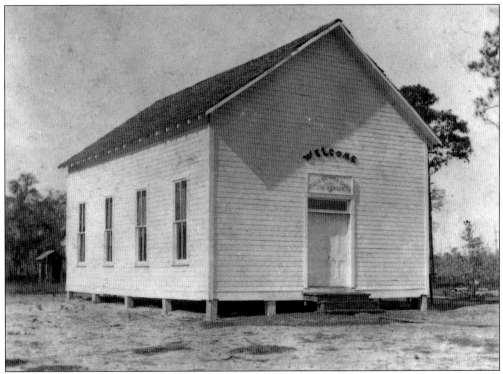

Rev. Issac Ward Bearss first established his church in a frame structure on the northern shore of Lake Carroll in 1895. As the congregation grew, George Gant provided land four miles west, just south of Gunn Highway off Normandie Road. It was there that the white, 24-by-36-foot frame structure in this photograph was dedicated in 1898 as the Shiloh United Brethren Church in Christ. (Courtesy of LMUMC.)

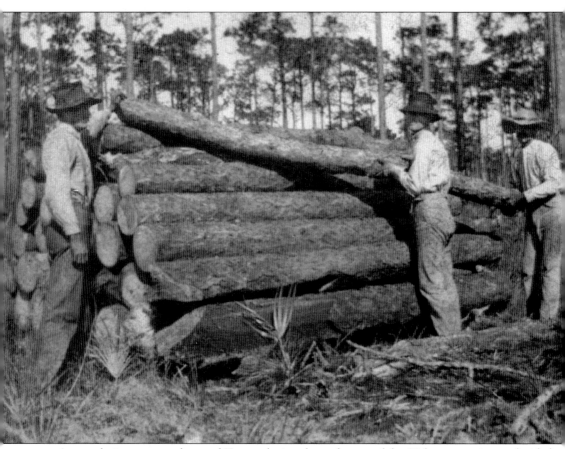

As populations swarmed toward Tampa during the early part of the 20th century, it was decided that the church should move closer to town. Berton and Clara Stall donated land at the church's current site at the southwest corner of modern-day West Fletcher Avenue and Paddock Avenue. The church was then moved on log rollers, which Berton Stall, Otterbein Bearss, and Markwood Bearss are seen working with here in this 1907 photograph. Utilizing a capstan, horses and mules, and 500 feet of rope, the church was moved over the course of 11 weeks, during which work would stop on Sunday, with services being held wherever they were along the way. The path from Normandie Road to the present site was zigzagged so the crew could minimize the removal of trees; only two trees were cut along the entire path. After the move was completed, the church became known as Lake Magdalene United Brethren Church in Christ. (Courtesy of LMUMC.)

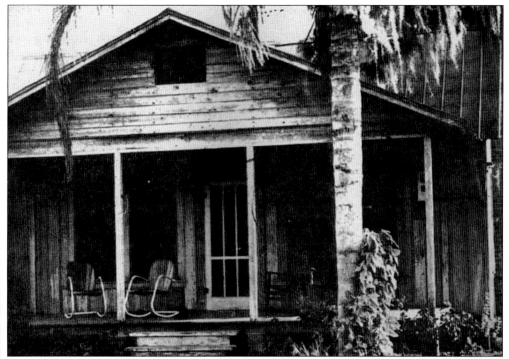

This frame structure was moved from Berton and Clara Stall's grove to a site about a block east of Paddock Avenue along modern-day Fletcher Avenue and became the church's first parsonage, a role the building would serve until 1914. (Courtesy of LMUMC.)

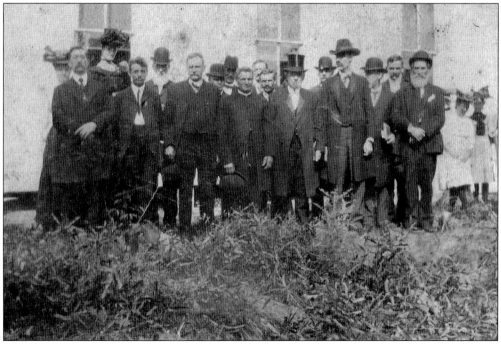

The Annual Conference at Lake Magdalene United Brethren Church in Christ is shown in 1907. At this time, Rev. George A. Cavanagh served as the church's pastor. (Courtesy of LMUMC.)

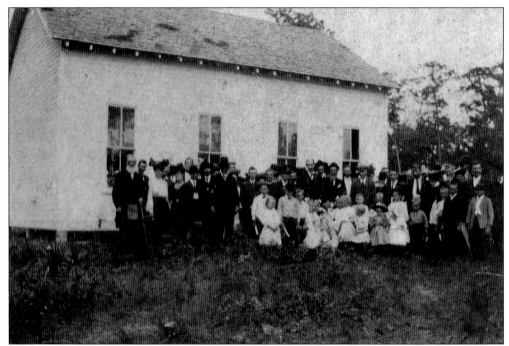

The 1910 Conference at Lake Magdalene United Brethren Church in Christ is seen in this photograph. Rev. Gideon Pillow Macklin served as the church's pastor at the time. (Courtesy of LMUMC.)

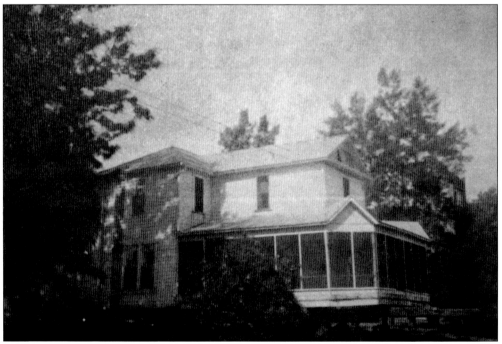

J.S. Betts was a local realtor who built this two-story house at what is now the southeast corner of Paddock Avenue and West Fletcher Avenue. Upon Betts's death, the church purchased the property and used the house as the second parsonage from 1914 to 1952. (Courtesy of LMUMC.)

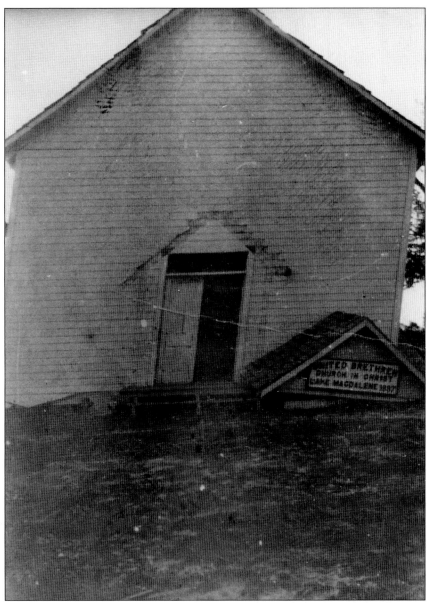

On October 25, 1921, a hurricane with sustained winds of 115 miles per hour made landfall near Tarpon Springs and tracked east over the Tampa area. Damages were substantial, as seen here in this photograph of Lake Magdalene United Brethren Church in Christ in the days just after the storm hit. Damages elsewhere in the Tampa area were heavy, with total destruction of many buildings near Ballast Point. More than eight inches of rain fell in Tampa and a storm surge ranging from 10 to 12 feet overwhelmed the bay, flooding much of the city. Damages were estimated at around $10 million in the Tampa area—a staggering sum at the time. However, recovery was hastened to help revive the image of the area in light of the land boom that Florida was enjoying in the 1920s. To date, the Tampa Bay Hurricane of 1921 was the last major hurricane to directly hit the area, though many other lesser tropical systems have skirted nearby since, reminding residents that Tampa is vulnerable to another hit by a massive storm like the one that struck the area so many years ago. (Courtesy of LMUMC.)

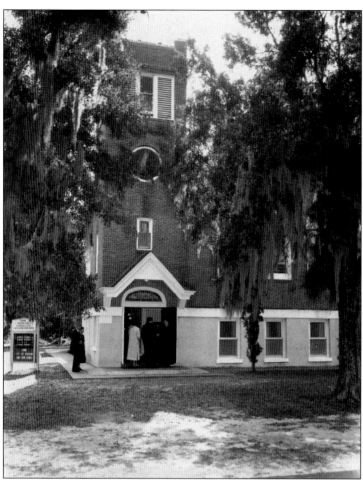

In January 1923, ground was broken on what was to become the church's second sanctuary. Constructed with bricks and soaring high above Lake Magdalene, the new church was completed in 1924 and dedicated on January 18, 1925. Costing $20,000, the new sanctuary was heralded as "Florida's finest rural church" by the *Religious Telescope*. (Courtesy of LMUMC.)

Members of the church celebrate Independence Day on July 4, 1926. Note the United States flag, which has only 48 stars. (Courtesy of LMUMC.)

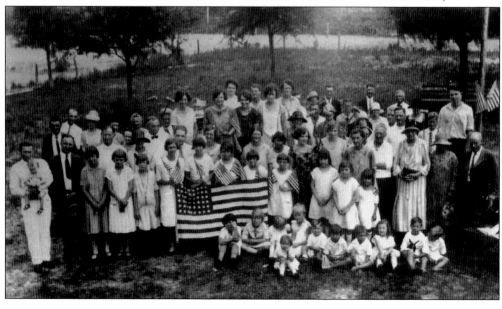

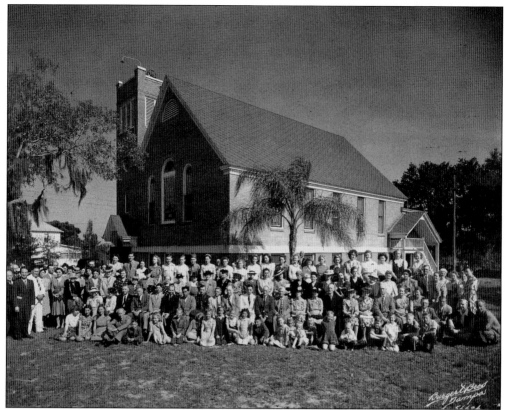

In May 1945, Lake Magdalene United Brethren Church in Christ celebrated its 50th anniversary with much fanfare. In this photograph, the exterior view of the sanctuary is seen with most of the church's members posing in the foreground. Incidentally, the bell tower seen in the top left of this image had been used during the previous few years as a lookout for German warplanes during the height of World War II. (Courtesy of LMUMC.)

This May 1945 photograph shows the interior of the church filled with members during the 50th-anniversary commemoration. Services were held on the second floor of the facility, with classes and other functions carried out on the first floor, which was two feet below ground level. (Courtesy of LMUMC.)

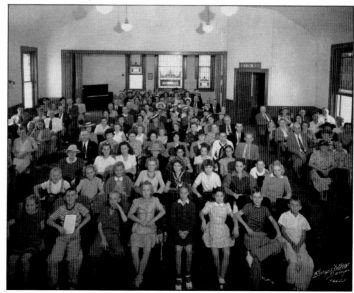

As membership grew at the church, which had been renamed Lake Magdalene Evangelical United Brethren Church in 1946, the decision was made to build a new sanctuary to accommodate the growing community. On June 7, 1959, a ceremony to break ground for the third sanctuary was held. (Courtesy of LMUMC.)

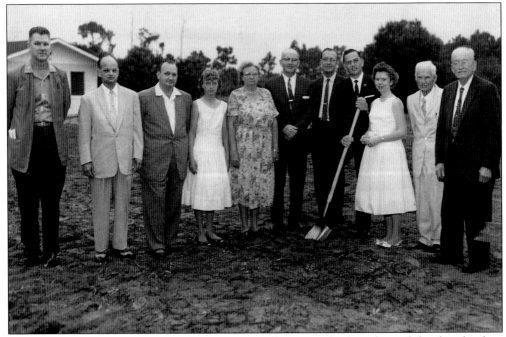

Attendees at the 1959 ceremony include Berton Stall, seen on the far right, and the church's then pastor Rev. William Obaugh, who is holding the shovel. (Courtesy of LMUMC.)

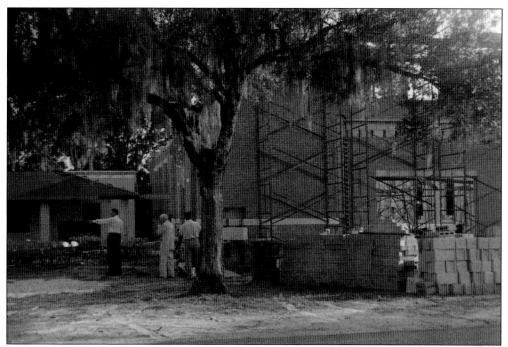

Construction of the third sanctuary is seen in late 1959. Scaffolding rises above what would become the front side of the church as concrete blocks stand in large piles just off the shoulder of Lake Magdalene Boulevard (modern-day Fletcher Avenue). (Courtesy of LMUMC.)

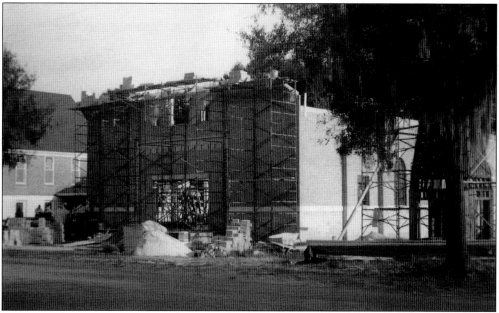

The new sanctuary continues to rise to the heavens in late 1959, as the front entranceway takes shape and openings form for stained-glass windows above. Off to the left, the 1924 sanctuary can be seen while what appear to be wooden roof trusses lie waiting for their installation toward the right side of this image. In the foreground is a two-lane version of what would become Fletcher Avenue. (Courtesy of LMUMC.)

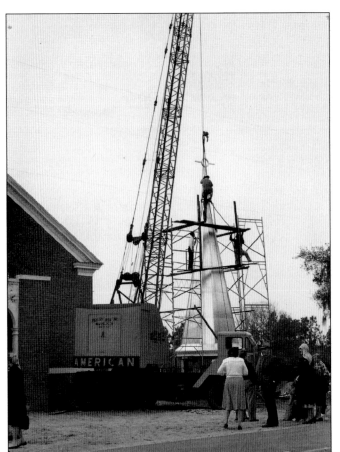

In very early 1960, a large crane is seen prepared to hoist the massive steeple that would cap off the exterior construction of the third sanctuary. Workers make final adjustments to the steeple's hoist connections as a crowd of onlookers gathers. (Courtesy of LMUMC.)

This 1960 aerial view of Lake Magdalene Evangelical United Brethren Church shows the completed third sanctuary off to the right of the image, while the second sanctuary remains on the left. Connecting the two in the middle is Fellowship Hall, which was dedicated on January 14, 1951, and used as a gathering place for Sunday school classes, banquets, and other events. (Courtesy of LMUMC.)

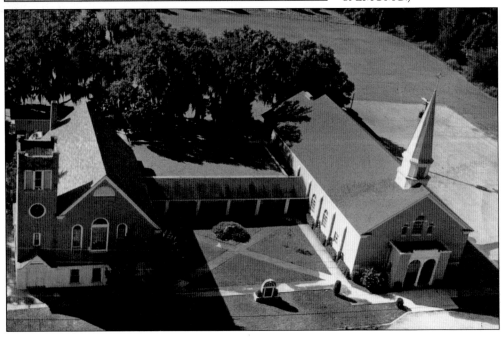

This photograph shows the interior of the lobby that greeted members as they walked into the main entrance of the third sanctuary. The double doors led to the main floor of the sanctuary, while the stairwell seen in this photograph would bring service attendants to the sanctuary's balcony section. (Courtesy of LMUMC.)

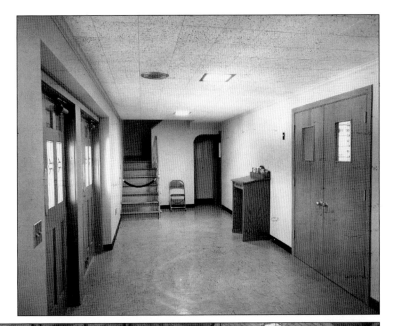

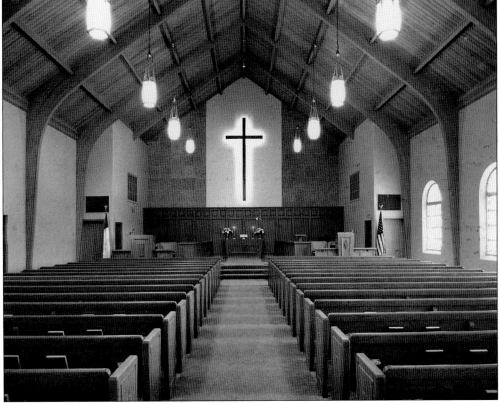

This view features the third sanctuary's vast interior, with soaring wooden ceilings, pews to accommodate hundreds of members, and a large cross overlooking the altar. The new church was consecrated by the presiding bishop, Dr. J. Gordon Howard, on March 20, 1960. (Courtesy of LMUMC.)

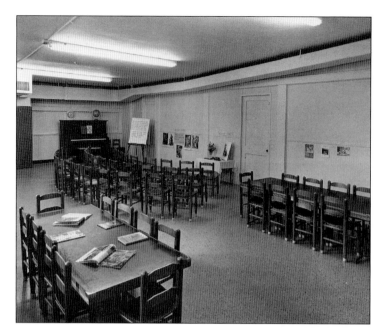

Seen in this 1950s photograph is the primary learning center at Lake Magdalene Evangelical United Brethren Church. The church has offered many educational and other youth services since its earliest decades, hearkening to the legacy of the greater community around Lake Magdalene and Lake Carroll, which has made educating its youth a priority since the area's days as an agricultural outpost. (Courtesy of LMUMC.)

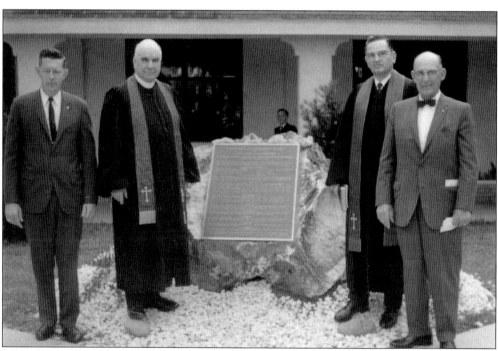

This photograph shows the dedication of the Founders' and Builders' Plaque, coinciding with the church's 70th anniversary on February 21, 1965. The plaque summarizes the history of the church up to that time and includes the motto "A glorious past, a challenging present, and a promising future." Pictured, from left to right, are Jay Stark, Bishop Dr. J. Gordon Howard, Rev. W.R. Obaugh, and George Cavanagh. (Courtesy of LMUMC.)

The church's 75th-anniversary diamond jubilee was celebrated on February 8, 1970. Events held that day included a program called "The Saga of an Old Pine Tree," which told the story of the church's growth from its modest beginning in pine woodlands. By this time, the church was called by its current name, Lake Magdalene United Methodist Church, signifying the unification of the Evangelical United Brethren Church and the Methodist Church in 1968. (Courtesy of LMUMC.)

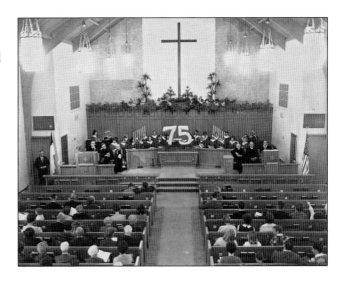

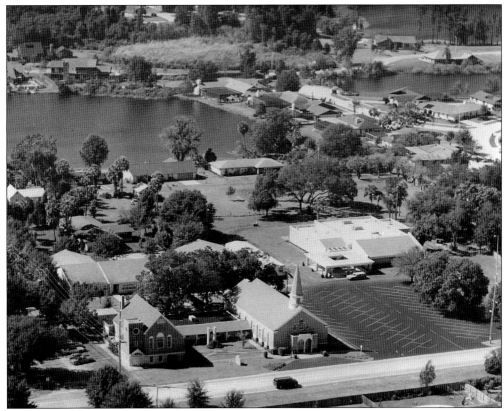

The growth of Lake Magdalene United Methodist Church reflected the expansion of the communities surrounding the church. This c. 1982 photograph provides a taste of the type of growth witnessed in the Carrollwood area during the 1970s and 1980s. Clusters of homes can be seen along Tifton Drive and Waterbury Lane in Lake Ellen Woods subdivision (right) where citrus, cypress, and open grass dominated just a decade earlier. (Courtesy of LMUMC.)

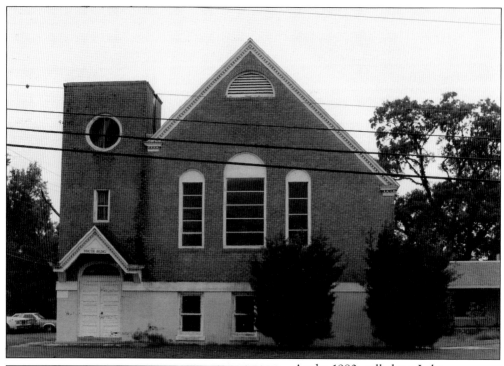

As the 1980s rolled on, Lake Magdalene United Methodist Church was preparing to expand again. The Christian Enrichment Center (CEC) would be built where the 1924 sanctuary stands in this mid-1980s photograph. This image was taken shortly before the old sanctuary's demolition. (Courtesy of LMUMC.)

The Christian Enrichment Center is seen in this photograph not long after its 1988 construction. The CEC is the venue for classes, various community organization meetings, and many other events. The four-story CEC is somewhat dwarfed today by the church's massive, fourth sanctuary, which replaced the 1960 structure in 2002. (Courtesy of LMUMC.)

Three

LAKE CARROLL AND ORIGINAL CARROLLWOOD

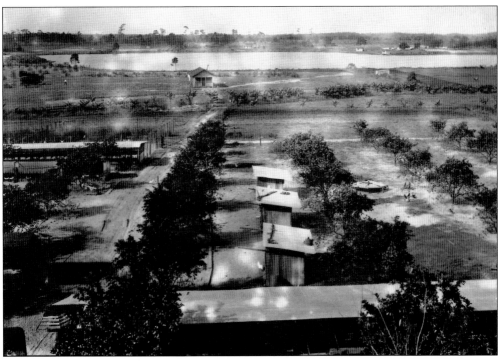

These plots of land, in the vicinity of Lake Carroll, are pictured November 19, 1925. This scene captures the essence of what would become Carrollwood before large-scale development came in during the late 1950s. Citrus trees can be seen throughout the landscape, as livestock roam near the middle of the view. One of the monikers of Lake Carroll at the time was "Horseshoe Pond," a name thought to have been linked to the horses that roamed near the lake during the earlier decades of the 20th century. (Courtesy of Tampa-Hillsborough County Public Library.)

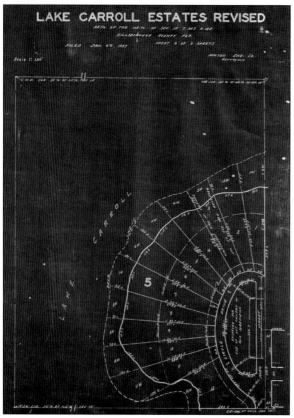

The Knowles residence is shown on March 10, 1924, at this unidentified location near Horseshoe Pond (Lake Carroll). This photograph further shows the major expanses of open land surrounding parts of the lake during those days. A couple of young citrus trees are growing in the foreground, while cypress stands dominate the distant background. (Courtesy of Tampa-Hillsborough County Public Library.)

This 1927 plat map shows the layout of the Lake Carroll Estates neighborhood, based around Circle Drive, which is now the western extent of Carroll Place. The small subdivision consisted of a dozen homesites that backed up to the southeastern shore of Lake Carroll. Most of the small homes that were built early in the development's history have been replaced by newer, much larger houses. (Courtesy of Tom Levin.)

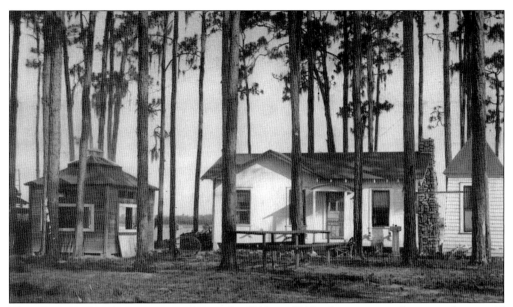

This photograph, taken sometime during the 1920s or 1930s, shows a typical cottage that would have stood near the shores of Lake Carroll during the day. Several of these lakeside cottages were the weekend homes for many of Tampa's wealthy city dwellers, who would spend leisure time enjoying the serene beauty of the lake and the fresh air of the peaceful country setting. (Courtesy of Deborah DeBose and Tom Levin.)

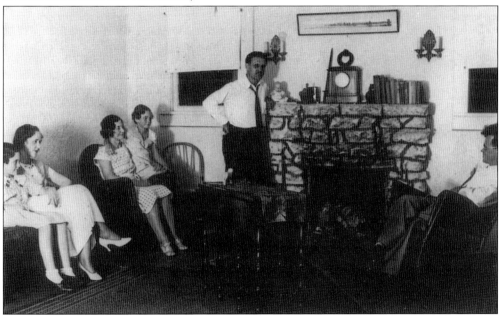

A family is seen relaxing inside their Lake Carroll cottage sometime during the 1920s or 1930s. Many of the homes that stood along the shores of Lake Carroll during this time would be considered tiny by contemporary standards, especially compared to some of the mansions that sprawl along the shores today. However, these quaint cottages provided ample room for families enjoying a weekend getaway from bustling Tampa seven miles to the south. (Courtesy of Deborah DeBose and Tom Levin.)

This family is enjoying a serene day on Lake Carroll on May 13, 1934. Note the vast expanse of open land behind the home near the shoreline. (Courtesy of the author.)

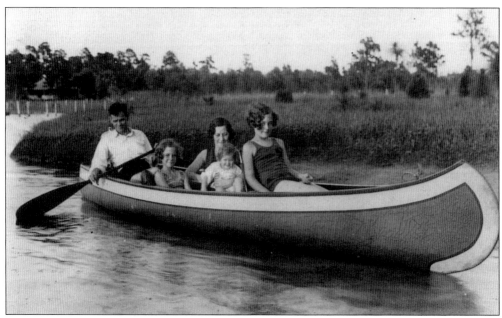

This 1920s or 1930s photograph shows a family canoeing through the clean waters of Lake Carroll. As also seen in the previous photograph, the shores of Lake Carroll were largely untouched by development. (Courtesy of Deborah DeBose and Tom Levin.)

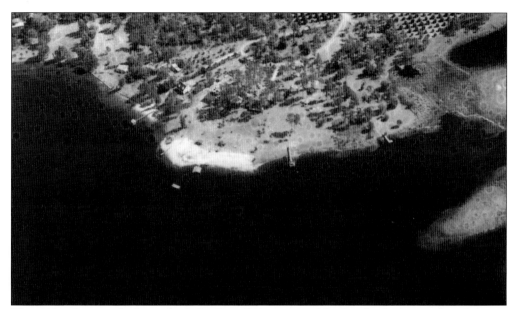

This 1954 photograph shows the Lake Carroll Estates neighborhood, which was platted during the 1920s and featured about a dozen homes situated along the southeast shore of Lake Carroll. The homes had addresses on Circle Drive, a street that is now called Carroll Place. (Courtesy of Tampa-Hillsborough County Public Library.)

This photograph shows the H.M. Ballinger home on May 24, 1957; it was located along Orange Grove Drive right near White Trout Lake. This was one of the few homes in the vicinity of the lake during the 1950s. (Courtesy of Tampa-Hillsborough County Public Library.)

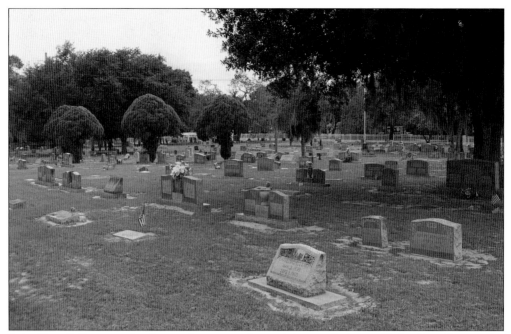

Lake Carroll Cemetery has been a fixture just beyond the north shore of Lake Carroll since the 19th century. The first burial recorded there was in 1877, when the property was owned by local Baptists. The northern part of the property was shared with Lake Magdalene United Brethren Church, which received the deed to the cemetery in 1946 and set up a perpetual fund to care for the grounds. (Courtesy of the author.)

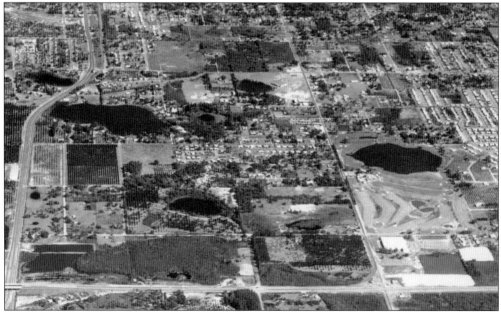

The original Carrollwood Country Club was located on the south side of Waters Avenue just east of Himes Avenue on the same property occupied today by the Lago Vista subdivision. This mid-1960s aerial image shows the golf course and the country club facility in the lower right. (Courtesy of Tampa Bay History Center Historical Collection.)

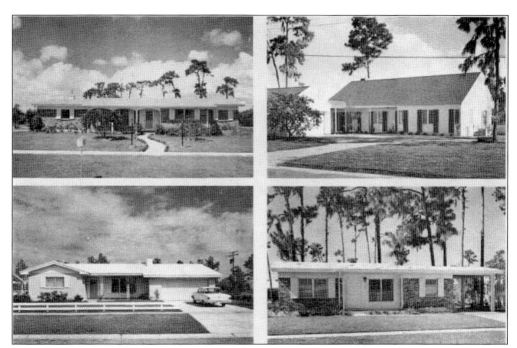

This image shows four homes that were built in Carrollwood during the early 1960s. Typical homes ranged in size from about 1,300 square feet to more than 2,000 square feet, coming in various styles as well as custom designs. (Courtesy of Deborah DeBose and Tom Levin.)

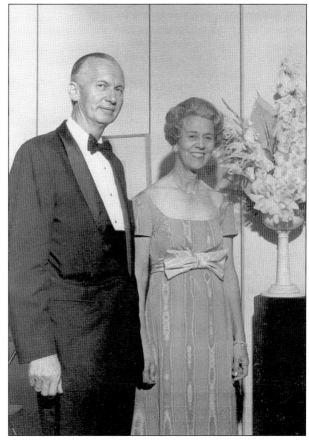

Perhaps two of the most famous early residents of Carrollwood were John Allen (first president of the University of South Florida) and his wife, Grace Allen. The president and first lady, seen here in this 1960s photograph, were very active in the community. Their strong advocacy of the university was instrumental in helping the young school thrive and grow during its first years. (Courtesy of USF Tampa Library Special & Digital Collections.)

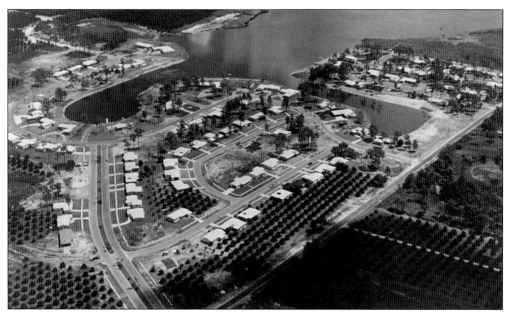

This very-early-1960s aerial photograph shows Carrollwood during its first years. While homesites along the shore of Lake Carroll had apparently been nearly built out by this point, there was still plenty of vacant land in the new subdivision, including a plethora of citrus trees left standing from the groves that dominated the land a few years earlier. (Courtesy of USF Tampa Library Special & Digital Collections.)

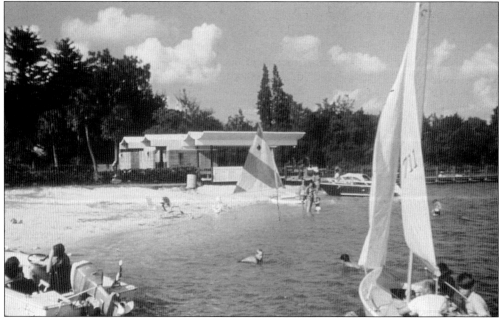

White Sands Beach is a private community beach that residents of the Original Carrollwood can access throughout the year. This photograph shows residents enjoying a sunny day on the northwestern shore of Lake Carroll. Meanwhile, the original shelter house, designed by Carrollwood architect Dean Rowe, AIA, and dedicated in 1965, stands prominently in the background. (Courtesy of Hillsborough County Planning Commission.)

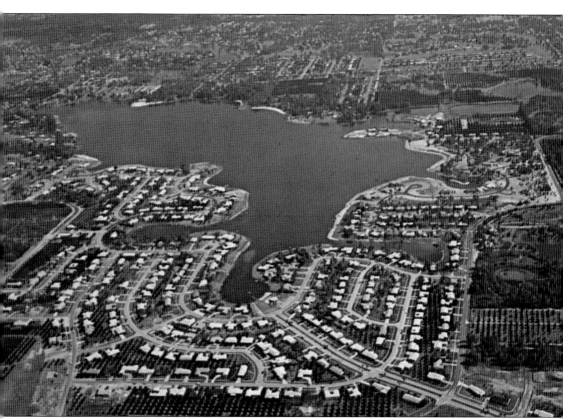

Carrollwood grew quickly throughout its first decade, as this 1960s postcard image testifies. Homes surround most of the western shore of Lake Carroll, with little vacant land remaining. While development had taken over the former orange grove property, partial rows of citrus still drew lines through many of the residential areas. It is interesting to note the apparent absence of fences and swimming pools in the yards of most of these homes. A look at the right side of this image reveals little development on the south side of Orange Grove Drive toward White Trout Lake. However, construction crews were in the process of developing the eastern reaches of Samara Drive; other streets toward the southeastern side of Lake Carroll were also just being built at the time of this photograph. (Courtesy of Carrollwood Recreation Center.)

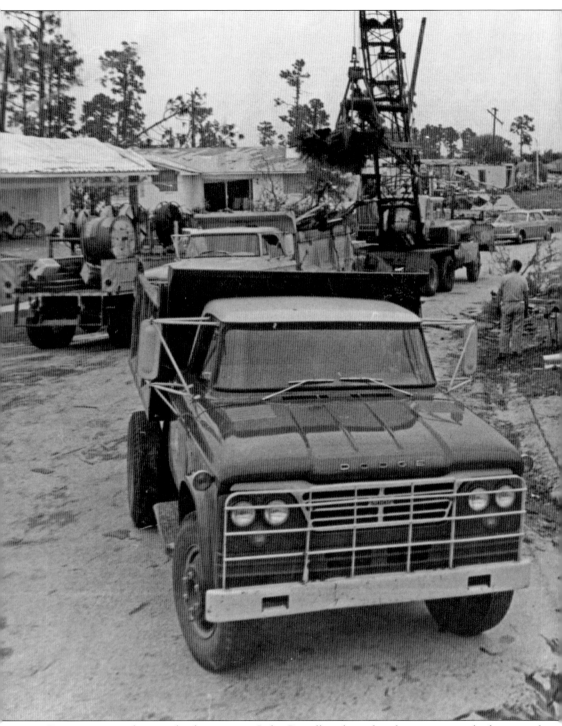

Recovery crews clean up the damage near Lake Carroll in the wake of a strong tornado that ripped through Carrollwood at around 8:20 a.m. on April 4, 1966. Severe tornadoes are extremely rare in Central Florida, which is one reason this terrible event took so many people by surprise. The tornado that caused the destruction in this photograph was estimated to have had winds of up

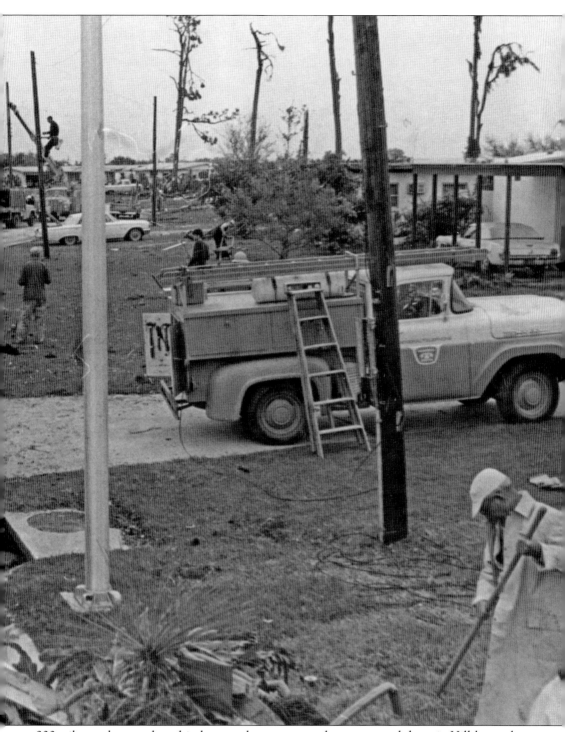

to 200 miles per hour and, to this day, was the worst tornado to ever touchdown in Hillsborough County. Eleven people died, more than 3,300 were injured, and over 250 homes were damaged or destroyed in the storms that ravaged Central Florida on that tragic morning. (Courtesy of the *Tampa Tribune*.)

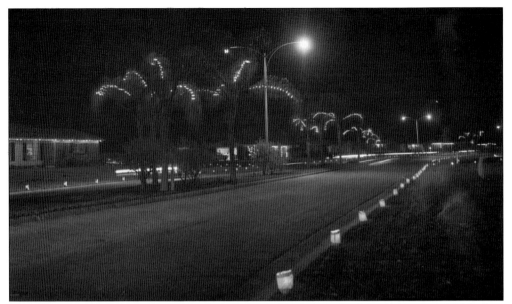

Carrollwood's popular Christmas Eve luminaria tradition dates back to 1960, when USF's then first lady Grace Allen wanted to recreate the beauty of tiny beacons that were used to adorn gardens in the Southwest. So she, along with local realtor Vera Beecher, presented the idea before the Carrollwood Civic Association. That Christmas Eve, the Carrollwood luminarias were born. They are seen here decorating Lake Carroll Way on December 24, 1966. (Courtesy of USF Tampa Library Special & Digital Collections.)

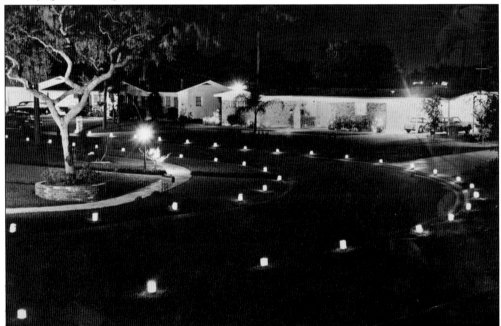

This unidentified street in Original Carrollwood is alight with the warm glow of luminarias on December 24, 1966. Usually, each homeowner would place luminarias on the street by his or her own yard, though neighbors typically would help each other as well, adding to the sense of community behind this tradition. (Courtesy of USF Tampa Library Special & Digital Collections.)

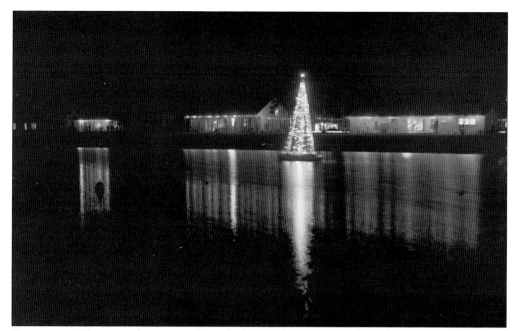

Extravagant Christmas decorations have decked the halls of Carrollwood since the community's early days. This Christmas tree–shaped decoration, illuminating the waters of Lake Carroll on December 24, 1966, is just one example of how the neighborhood has always marked the holiday season in festive style. (Courtesy of USF Tampa Library Special & Digital Collections.)

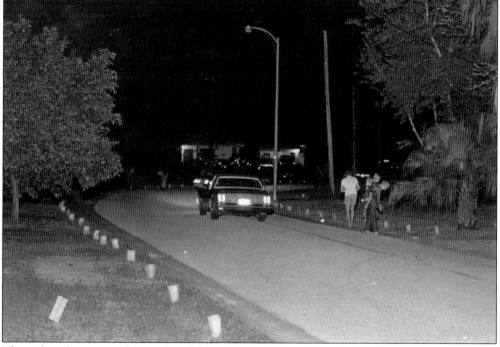

The styles of cars may change, but the luminarias in Carrollwood carry on year after year. This Christmas Eve tradition is pictured about 1980 somewhere in Original Carrollwood. (Courtesy of Carrollwood Recreation Center.)

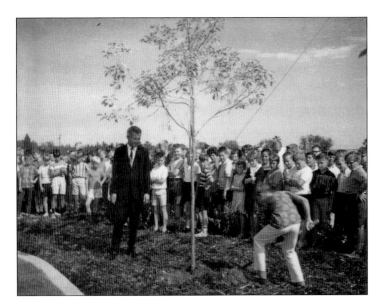

A boy is seen in June 1967 planting a camphor tree, while Matt Jetton watches over during the dedication of the Carrollwood Children's Mall, a 100-by-60-foot landscaped area that connected Valencia Drive with Carrollwood Elementary School. (Courtesy of Carrollwood Elementary School.)

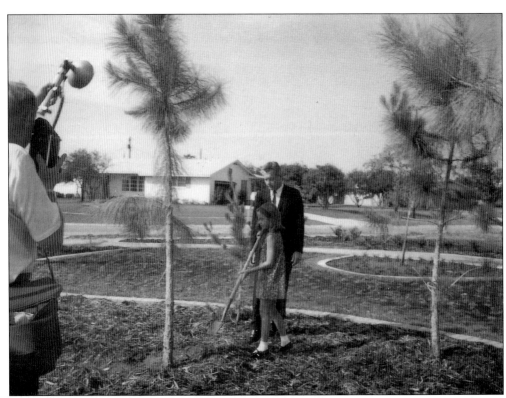

An unidentified girl helps establish a slash pine as Matt Jetton observes the ceremonious planting in the landscaped mall that his company, along with the Hillsborough County Commission, Carrollwood Garden Club, and Carrollwood Civic Association, gifted to Carrollwood Elementary School in June 1967. (Courtesy of Carrollwood Elementary School.)

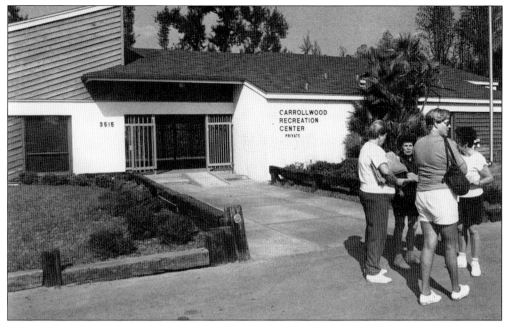

This January 29, 1986, photograph shows the Carrollwood Recreation Center, which opened in 1975. Located at 3515 McFarland Road, the original recreation center was 3,000 square feet and served as a gathering place for many community events over the years. In 2007, the old recreation center was replaced with a 4,500-square-foot facility. (Courtesy of the *Tampa Tribune*.)

The 1971 dedication of the original flagpole and flag at White Sands Beach coincided with the community's Fourth of July celebration, an event the patriotic community has celebrated in grand fashion since its earliest days. (Courtesy of Carrollwood Recreation Center.)

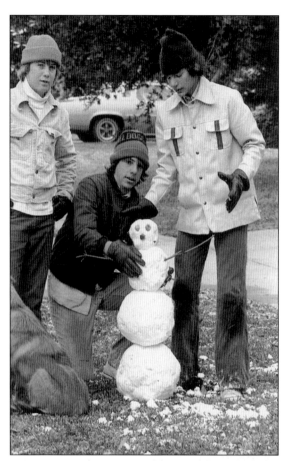

On January 19, 1977, a strong Arctic weather system showered snow over Tampa as temperatures dropped to 28 degrees and the right amount of air moisture settled in. Snow accumulation in Central Florida is quite rare, so these three young men took advantage of the occasion and built a snowman before the slushy, white precipitation melted away. (Courtesy of Carrollwood Recreation Center.)

Snowmen sightings were rampant throughout Carrollwood on the morning of January 19, 1977. This little snowman, held by Jeannette Hale Babione (left) and Laura Clapp Eiras, probably did not very much like the 50-degree high temperature that would come later that day. (Courtesy of Carrollwood Recreation Center.)

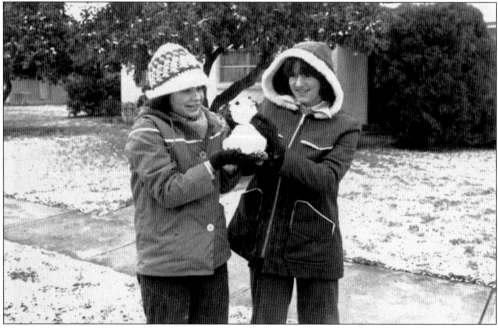

The miniature "Blizzard of '77" brought a lot of ice to the Tampa area, so Katherine Clapp decided to check the citrus trees around her Carrollwood home to see if they survived the unusually chilly morning temperatures. (Courtesy of Carrollwood Recreation Center.)

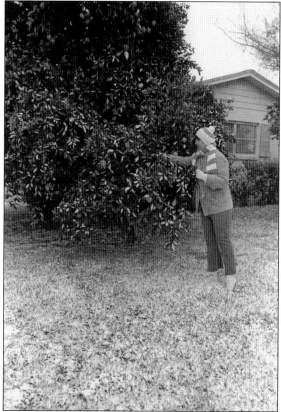

It is not too often Tampa kids get to enjoy a snowball fight, but the 1977 snowstorm allowed these children in Carrollwood to lob a few snowballs at each other—against the very Floridian backdrop of palms, nonetheless. (Courtesy of Carrollwood Recreation Center.)

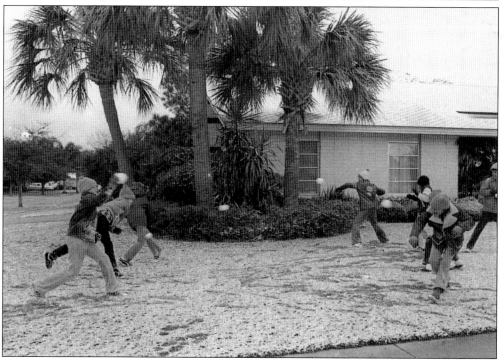

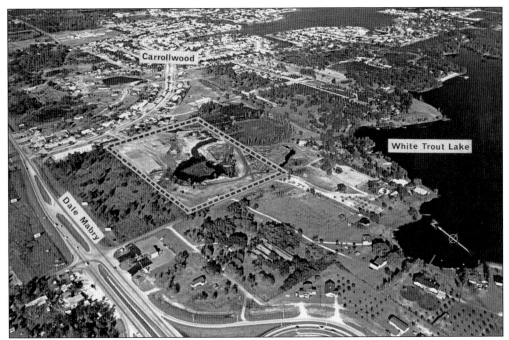

In this 1969 aerial photograph, a box is drawn in that shows where a future apartment complex would be constructed. Note here that North Dale Mabry Highway narrows to two lanes just south of Floyd Road and Carrollwood Center shopping plaza only includes a small strip of stores facing Lake Carroll Way. (Courtesy of the *Tampa Tribune*.)

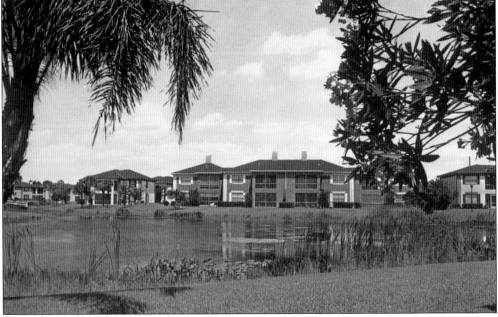

The apartment community described in the previous photograph, later converted to condominiums, would eventually be known as the Grand at Olde Carrollwood. This 1969 photograph shows the community's parklike environs, in which 244 residential units are situated around a pond. (Courtesy of Florida State Archives.)

Four

CITRUS, CYPRESS, AND CHICKENS

This 1913 advertisement by the North Tampa Land Company epitomizes the opportunity to enjoy Florida living at its finest. The company bought 32,000 acres of land in northern Hillsborough County and parceled out tracts to thousands of customers. Some of this land includes parts of the Carrollwood area as well as much of Lutz to the north. (Courtesy of the author.)

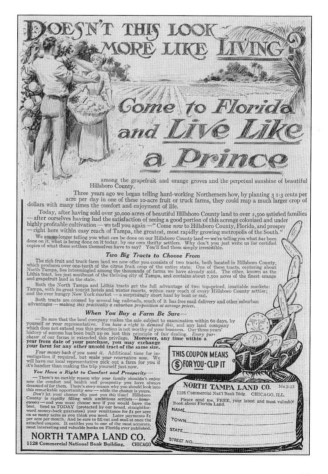

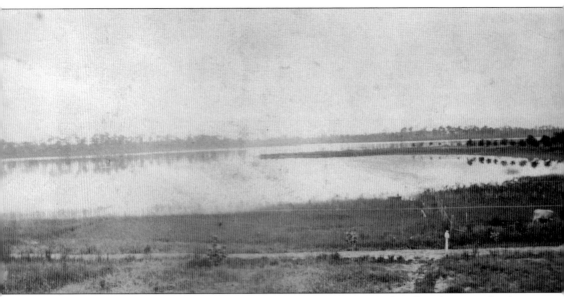

This 1920s panoramic photograph of Lake Magdalene shows little other than stands of cypress and pine surrounding the 206-acre, freshwater lake. There are several theories as to how the lake got its name. One legend says the vision of Mary Magdalene once appeared before an early settler near the lake. Another story suggests the name comes from Magdalena, the moniker of a Native American woman who was an interpreter for Spanish explorers arriving in Florida in 1549. However, by virtually all other accounts, the name comes from an 1882 marriage that occurred near the lake on the property of the groom's family. The wedding was for John Parrish and Mary Magdalene Yates, who was the daughter of Jonah Yates, the first mayor of Plant City. The wedding was a gala event that lasted two days and drew guests from all over Hillsborough County; speeches were given, there were dances, and Grandma Parrish named the lake in honor of the bride. (Courtesy of the Paul Bearss family.)

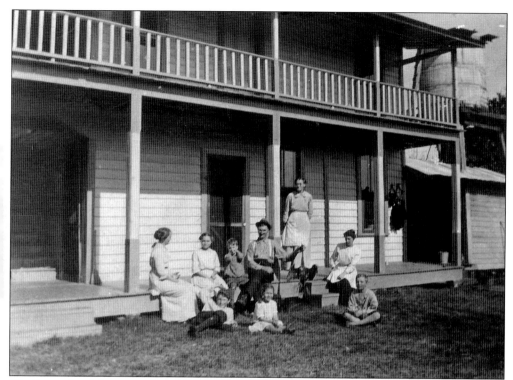

The Bearss family homestead is seen in this 1906 photograph. It was located about a block southeast of where Bearss Avenue and Lake Magdalene Boulevard intersect today near the northwest shore of the lake. (Courtesy of the Paul Bearss family.)

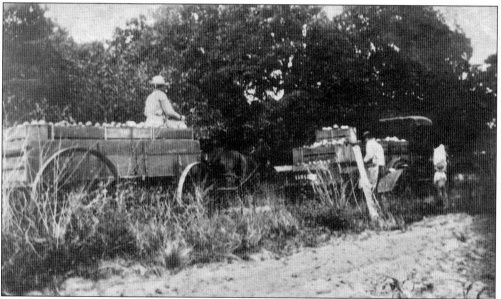

Harold Bearss is seen in this undated photograph tending to the groves on the family property. The Bearss family originally had 600 acres of land mainly around the northwestern shore of Lake Magdalene, and much of this property was used to grow varieties of citrus. (Courtesy of the Harold Bearss family.)

Markwood Bearss is seen in this undated photograph steering a mule-driven coach along a gravel road presumably located somewhere in the vicinity of Lake Magdalene. (Courtesy of the Harold Bearss family.)

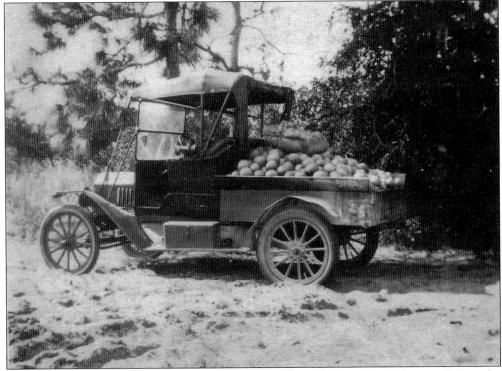

This 1910s photograph shows the fruit truck that Markwood Bearss would drive to deliver the family's produce. (Courtesy of the Harold Bearss family.)

Motoring through an Orange Grove.
Tampa, Florida.

This 1920s postcard exemplifies what much of Hillsborough County looked like in the first half of the 20th century. In many areas throughout northwest Hillsborough County, countless rows of orange trees would line roads as far as the eye could see. Not surprisingly, citrus production, along with other agricultural activities in Hillsborough County, was a major facet of the local economy at the time and remains so even today. (Courtesy of USF Tampa Library Special & Digital Collections.)

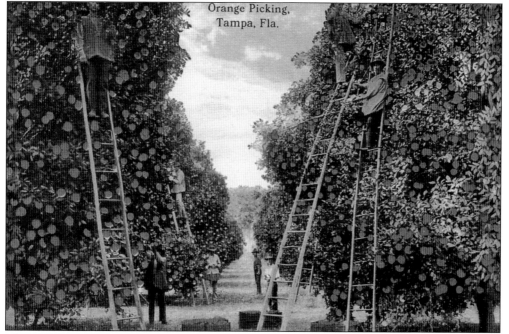

Orange Picking,
Tampa, Fla.

This 1910s postcard represents a common scene around the lakes of the Carrollwood area during citrus harvesting time, as laborers ascend ladders to pick oranges in the groves. By 1920, the state of Florida was producing more than seven million boxes of oranges a year, a figure that would double at one point within a decade. (Courtesy of USF Tampa Library Special & Digital Collections.)

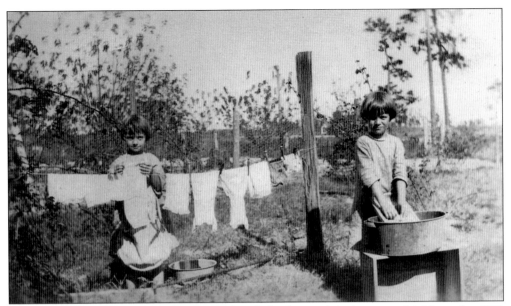

Decades ago, even the youngest family members helped around the house, as this November 1921 photograph shows. On the right, Bernice Stall launders dolls' clothing on a washboard, while Kathryn Stall hangs the tiny apparel on a clothesline. (Courtesy of the Stall family.)

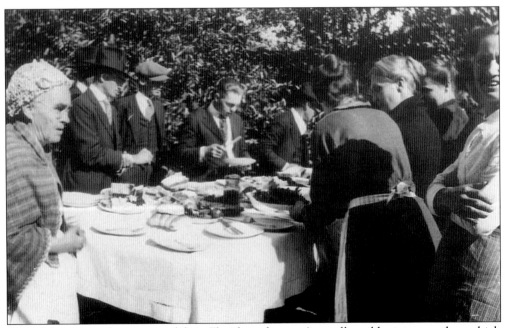

One of the many advantages to life in Florida is the state's usually mild winter weather, which made this Christmas 1922 outdoor dinner near Lake Magdalene a bearable event. Large holiday dinners around Lake Magdalene in the earlier parts of the 20th century were often community events where everyone pitched in and brought something delicious to the table. (Courtesy of the Stall family.)

Otterbein Bearss is working the fields by mule in this undated photograph. Outdoor labor was virtually an everyday affair for the family, who grew oranges and were involved in many other agricultural activities since their earliest days on the shores of Lake Magdalene. (Courtesy of the Paul Bearss family.)

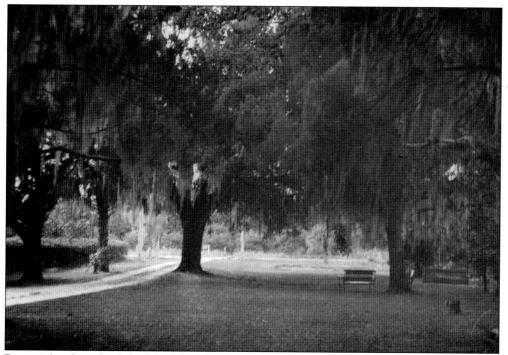

Route 1 (modern-day Lake Magdalene Boulevard) is seen tracing by the Bearss property in front of Otterbein Bearss's house. While decades have passed since this photograph was taken, much of the property along the northwestern shore of Lake Magdalene looks remarkably similar today. (Courtesy of the Paul Bearss family.)

This March 1927 photograph was taken just outside of the Bearss family property off modern-day Lake Magdalene Boulevard. This image clearly shows the rural surroundings of the Lake Magdalene Boulevard area during the 1920s, right down to the dirt road. (Courtesy of the Stall family.)

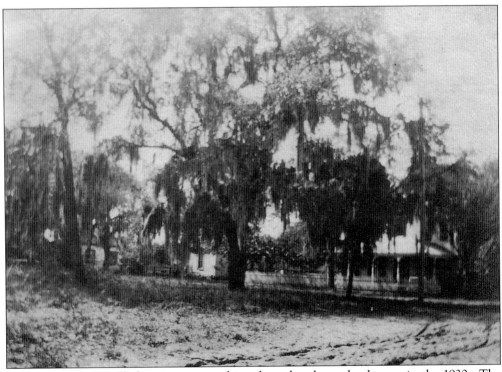

Berton and Clara Stall's home is seen peeking through palm and oak trees in the 1930s. The home was located along Paddock Avenue adjacent to Lake Magdalene church. (Courtesy of the Paul Bearss family.)

The main elevation of Berton and Clara Stall's two-story home is seen in this 1960s-era photograph. As the decades wore on, the home would become one of the oldest in the area. (Courtesy of the Harold Bearss family.)

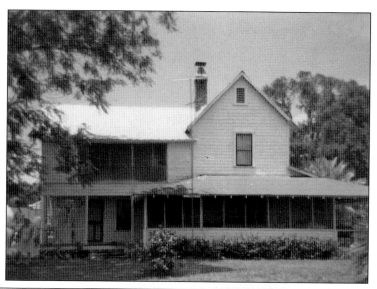

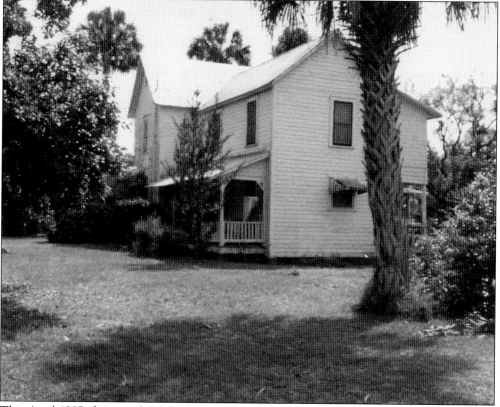

This April 1987 photograph of the Berton and Clara Stall home shows how it looked not long before its demise. The old Stall home is a prime example of the types of older frame houses that dotted some of the Carrollwood landscape even into the 1970s and 1980s, as newer developments encroached. While most of the homes that belonged to early Carrollwood residents have since succumbed to sprawl, there are still some pre-1950s structures standing, particularly in the northern areas around Lake Magdalene. (Courtesy of the Paul Bearss family.)

This 1940s-era photograph, taken from the Bearss family property, shows a row of junipers leading down to the virtually untouched northwest shoreline of Lake Magdalene. Note that there are still no obvious signs of development on the opposite shore of the lake. (Courtesy of the Paul Bearss family.)

A 1940s-era close-up of Lake Magdalene shows not only no residential development along the opposite shoreline but also empty land as far as the eye can see (well beyond the shores). The rural character of the lake and its surroundings would remain throughout the next decade. (Courtesy of the Paul Bearss family.)

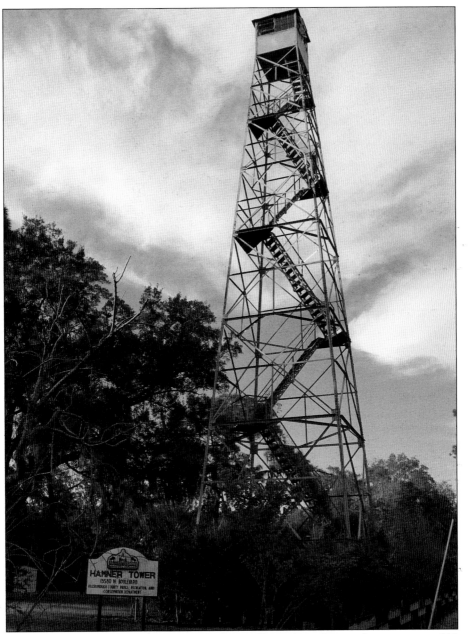

One relic from the Carrollwood area's early days still stands at the northwest corner of North Boulevard and West Fletcher Avenue. The Hamner Fire Tower was manufactured by the Aermotor Co. in Chicago, Illinois, and built by the Florida Forest Service (FFS) in 1937. The lookout tower was named for Forest Hills developer B.L. Hamner and was used for decades to monitor the vast expanses of land surrounding Lake Carroll, Lake Magdalene, Lake Ellen, and other areas for many miles around. The tower's existence would be threatened as suburban developments sprang up all throughout the latter part of the 20th century, causing local residents to rally for preservation of the metal structure and the eight acres of land that it sits on. In 1995, Hillsborough County designated the Hamner Fire Tower as a historic landmark, and the 85-foot-tall structure stands to this day as a reminder of northwest Hillsborough County's rural past. (Courtesy of the author.)

Besides citrus crops, farmers raised livestock in the earlier part of the 20th century in Carrollwood. This large chicken coop, pictured on May 5, 1955, was located on a farm near Lake Magdalene; there were many other farms similar to this in the Carrollwood area at the time. (Courtesy of Tampa-Hillsborough County Public Library.)

Turner Dairy barn, pictured on September 30, 1949, was located on Gunn Highway west of Casey Road. Turner Dairy was a popular spot for milk, ice cream, and other farm-fresh goods, but development took over in the mid-1970s, when the Plantation of Carrollwood subdivision was built. (Courtesy of Tampa-Hillsborough County Public Library.)

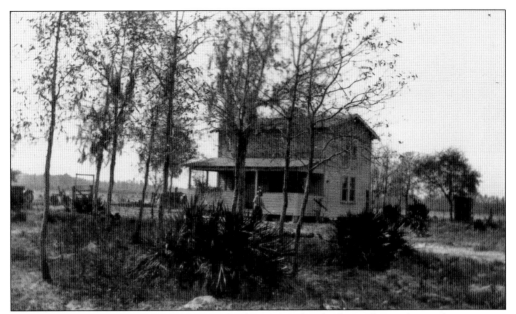

This 1946 photograph shows the home of Charles H. Handy, which stood near the southwest corner of where North Dale Mabry Highway and Handy Road intersect today; modern-day Handy Road traces the path of the original driveway that led to the home from Ehrlich Road. The property consisted of 200 acres of stumpland, of which eight acres became citrus groves only a few months after the Handys' arrival in Florida during Thanksgiving 1921. (Courtesy of Paul Handy.)

This c. 1960 aerial photograph shows the steeple of Lake Magdalene Evangelical United Brethren Church standing tall across from the citrus groves that grew just north of modern-day Fletcher Avenue. This image not only emphasizes the dominance of the citrus industry in northwest Hillsborough County but also the fact that substantial residential development around much of the Lake Magdalene and Lake Ellen areas was still largely absent even in the 1960s. (Courtesy of LMUMC.)

As the decade of the 1970s marched along, suburban development would stampede north of Fletcher Avenue and begin taking over many of the citrus groves seen earlier in this chapter. However, the sweet smell of blossoming citrus trees still lingered around parts of Lake Magdalene, as this August 1973 photograph of flourishing citrus trees in the vicinity of the lake would indicate. (Courtesy of Hillsborough County Planning Commission.)

Old Man Winter made several appearances in Central Florida during the 1980s, much to the chagrin of Paul Bearss, who is seen in this 1987 photograph replanting 40 acres of citrus groves that were destroyed in a freeze. This grove was one of the last remaining vast stretches of citrus-tree coverage in the Carrollwood area and was developed beginning in 2012 as the 94-home Retreat at Carrollwood subdivision. (Courtesy of the Paul Bearss family.)

Five

ROAD TRIP

A two-lane Dale Mabry Highway is seen in this view looking south at its intersection with Gunn Highway on June 18, 1959. This image, taken from an overpass that crosses railroad tracks (and now also Busch Boulevard, which was built a few years after this scene was photographed), shows the vicinity of the Carrollwood area at about the time Matt Jetton would begin building homes around Lake Carroll. Note the area was still largely rural at that time. (Courtesy of Florida State Archives.)

The view in this image looks north toward the intersection of Gunn Highway and North Dale Mabry Highway on June 18, 1959. At the time, the overpass in the center background only crossed railroad tracks. The portion of Gunn Highway adjacent to Dale Mabry Highway would be realigned with Temple Terrace Highway (renamed Busch Boulevard in 1968), which was extended westward to Dale Mabry in 1965. Today, the only remaining segment of Gunn Highway south of the Busch Boulevard overpass has been renamed Lazy Lane. (Courtesy of Florida State Archives.)

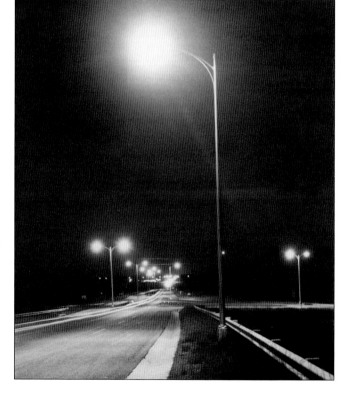

The only lights seen in this southward-looking night view along a stretch of North Dale Mabry Highway near Gunn Highway on June 18, 1959, are those coming from streetlamps and a few vehicle headlights. No strip malls, no restaurants, and no traffic lights—just acre upon acre of wetland and woodland welcomed motorists driving northward into what would become known as Carrollwood. (Courtesy of Florida State Archives.)

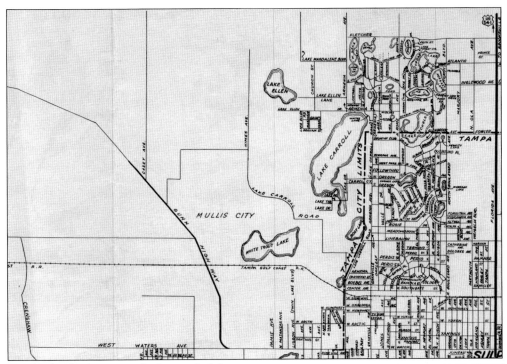

North Florida Avenue is the heavy dark line along the right side of this 1953 map, and Gunn Highway is the long, curved line on the left half of the image, intersecting with West Waters Avenue along the bottom. While Forest Hills was largely built out just to the east of Lake Carroll, only a few residential streets are indicated on this map west of Armenia Avenue. Note the absence of North Dale Mabry Highway, which terminated at Hillsborough Avenue until the mid-1950s. (Courtesy of USF Tampa Library Special & Digital Collections.)

This 1970 map shows that, by the end of the 1960s, Matt Jetton's Carrollwood subdivision was virtually built out. For reference, North Dale Mabry Highway is indicated by the heavy line along the left side of this image and Busch Boulevard is represented by the thick line meandering near the bottom. Note that the area north of Fletcher Avenue (which is about midway up the image) was still largely undeveloped, though the neighborhoods in the vicinity of Leisure Avenue had begun popping up just east of Lake Magdalene. (Courtesy of USF Tampa Library Special & Digital Collections.)

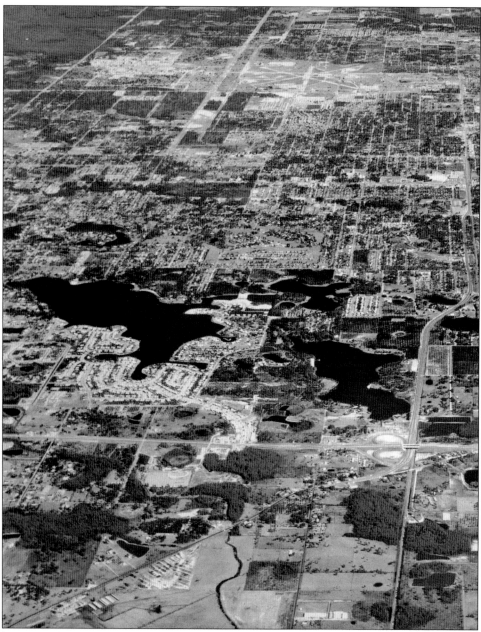

The view in this c. 1965 aerial photograph looks east, with Turner Dairy in the lower left foreground, Lake Carroll in the center left, and White Trout Lake on the center right. Busch Boulevard (then called Temple Terrace Highway) had been built through from North Florida Avenue to North Dale Mabry Highway not long before this time; the southern and western shores of Lake Carroll were largely developed, and there appears to be little indication of commercial activity along North Dale Mabry Highway, though Hudson Nursery, Carrollwood State Bank, and some early stores at Carrollwood Center facing Lake Carroll Way were already in business. In the top third of this photograph, Interstate 275 had not yet been built through yet, and near the very top is Henderson Airport, with runways across much of the land surrounding Busch Gardens. (Courtesy of Tampa Bay History Center Historical Collection.)

Anderson Road can be seen intersecting with Waters Avenue on August 1, 1958. Toward the north, very little other than cypress stands and open fields can be seen. However, near the upper right corner is the Four Oaks community just north of Gunn Highway. (Courtesy of Tampa-Hillsborough County Public Library.)

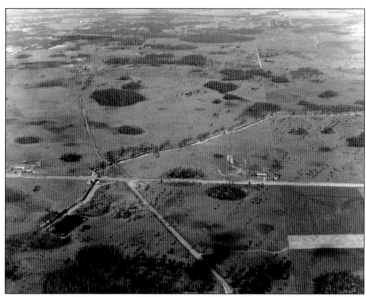

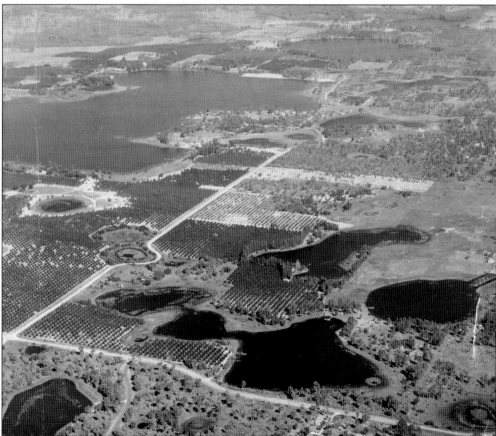

West Fletcher Avenue is seen crossing the bottom of this c. 1940 photograph, while North Rome Avenue traces diagonally up the middle. This image also features the many acres of citrus groves that grew southeast of Lake Magdalene, in the upper left corner. (Courtesy of Tracy Ryan.)

The intersection of North Dale Mabry and Sligh Avenue, pictured on August 19, 1958, shows very little existed along the corridor, except for a gas station at the southeast corner of the juncture. Had this photograph been taken today, Florida Hospital Carrollwood would consume a large part of the scene just to the right of North Dale Mabry Highway, about a block north from where this photograph was taken. (Courtesy of Tampa-Hillsborough County Public Library.)

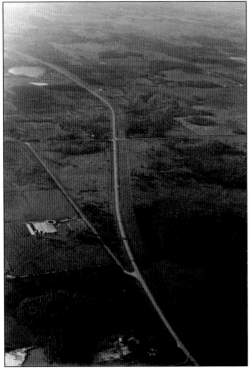

North Dale Mabry Highway is seen heading south toward Ehrlich Road about 1963, while Zambito Road extends out from the highway toward the center left. Carrollwood Village would sprawl across the top right of this image if it were taken today, while shopping malls anchored by Walmart and Target would flank, left and right respectively, North Dale Mabry Highway in the center of the photograph. (Courtesy of Hillsborough County Planning Commission.)

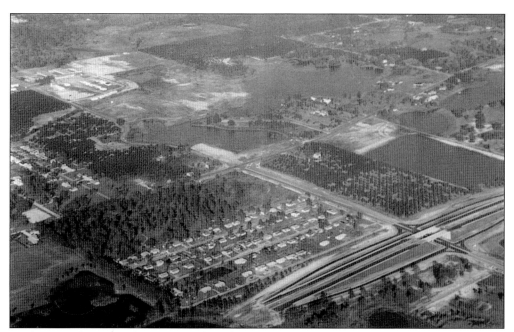

Looking northwest in this c. 1963 photograph, Bearss Avenue can be seen intersecting with Interstate 275, while homes already existed along Connie Avenue (center left) and Monaco Drive (near the upper left corner). Buchanan Middle School sits just to the left of the large sandy field in the vicinity of Monaco Drive. (Courtesy of Hillsborough County Planning Commission.)

From above, Lamps Pond (lower left) is pictured at the northwest corner of the West Bearss Avenue and North Florida Avenue intersection on February 16, 1959. Toward the west, Lake Magdalene (upper left corner) and Platt Lake (above center) are visible. (Courtesy of Tampa-Hillsborough County Public Library.)

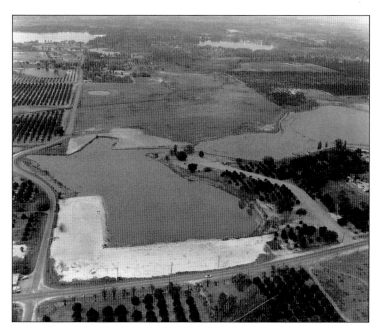

West Bearss Avenue used to bend around the southern side of Lamps Pond, but this stretch of road was straightened during the widening of Bearss Avenue in the late 1980s. Another interesting feature in this c. 1963 photograph is the orange grove to the right, which stands on the same land that Bearss Plaza occupies today at the southwest corner of Bearss Avenue and North Florida Avenue. (Courtesy of Tampa-Hillsborough County Public Library.)

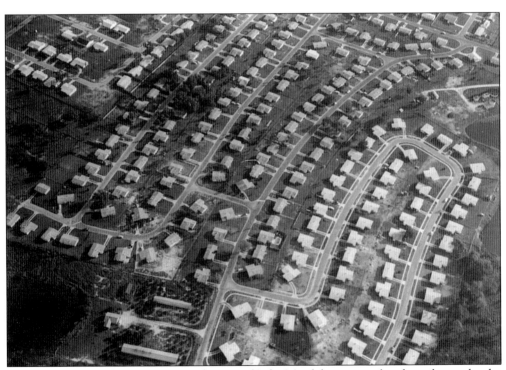

The first major developments just to the east of Lake Magdalene were already underway by the early 1960s, and the houses seen in the vicinity of Leisure Avenue, which trails from the bottom of this c. 1963 image to the upper right corner of the photograph, were among the first tract homes in the area. (Courtesy of Hillsborough County Planning Commission.)

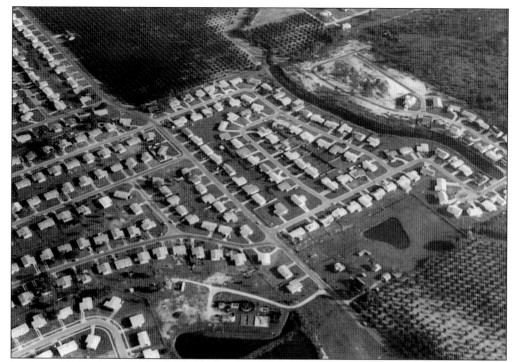

In this c. 1963 photograph, North Boulevard Avenue stretches from the top left corner of the image down to the bottom right, with tract homes flanking both sides of the road. The orange grove below would become the northern reaches of the North Pointe subdivision around 1974, while the orange grove above would be developed into the Settlers Pointe community by 1980. (Courtesy of Hillsborough County Planning Commission.)

This is a view along North Florida Avenue looking north to the road's intersection with Fletcher Avenue on February 6, 1954. A bank stands today where Meli's Place restaurant (the white structure on the left) is located. While this area would see tremendous growth in the immediate two decades to follow, North Florida Avenue would remain two lanes wide throughout most of its run in this area of the county into the early 1990s. (Courtesy of Tampa-Hillsborough County Public Library.)

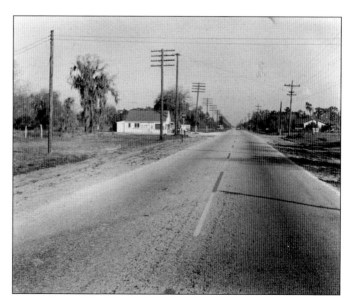

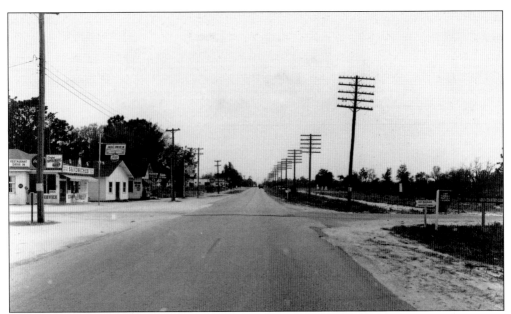

A view of Florida Avenue looking south toward its intersection with Linebaugh reveals there were only a handful of businesses—and no apparent car dealerships—along this part of the corridor on April 2, 1951. The signs just off the shoulder of North Florida Avenue, in the center right of the image, point to Lake Carroll Baptist Church, Lake Magdalene Evangelical United Brethren Church, and the Forest Hills Golf & Country Club. (Courtesy of Tampa-Hillsborough County Public Library.)

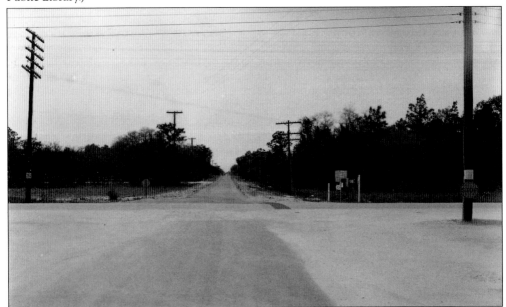

This view looks west along Linebaugh Avenue as it crosses North Florida Avenue on April 2, 1951. Driving west along the stretch of Linebaugh Avenue seen disappearing into the background here would have been one of the few routes to reach Lake Carroll and Lake Magdalene from many areas of North Tampa, especially before the extension of Dale Mabry Highway north of Hillsborough Avenue in the mid-1950s. (Courtesy of Tampa-Hillsborough County Public Library.)

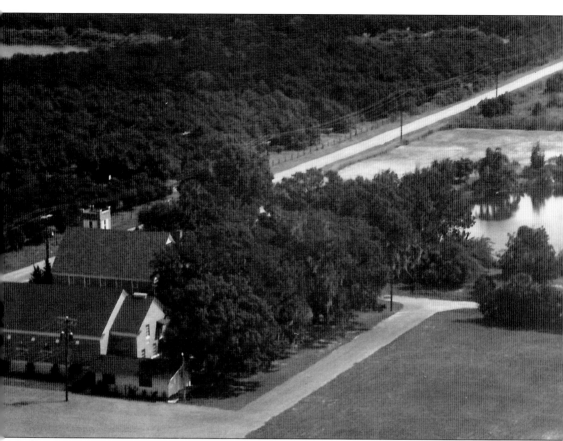

This early-1960s view shows Lake Magdalene Evangelical United Brethren Church in the lower left standing before Lake Magdalene Boulevard. Back in these days, Lake Magdalene Boulevard (also referred to as Route 1) was one of the main roads that traveled around Lake Magdalene. The portion of Lake Magdalene Boulevard that stretches across the image here would be widened to four lanes and be renamed West Fletcher Avenue in the latter part of the 1980s. In the upper left, Lake George is pictured before developments such as Lake Magdalene Arms and Lake George Estates would be constructed in the 1970s. Note how residents living around Carrollwood's lakes were remote from urban life up through the 1960s. About the only open land in this photograph that remains to this day is the sandy patch in the center right. Today, that spot serves as a sports field for Lake Magdalene United Methodist Church. (Courtesy of LMUMC.)

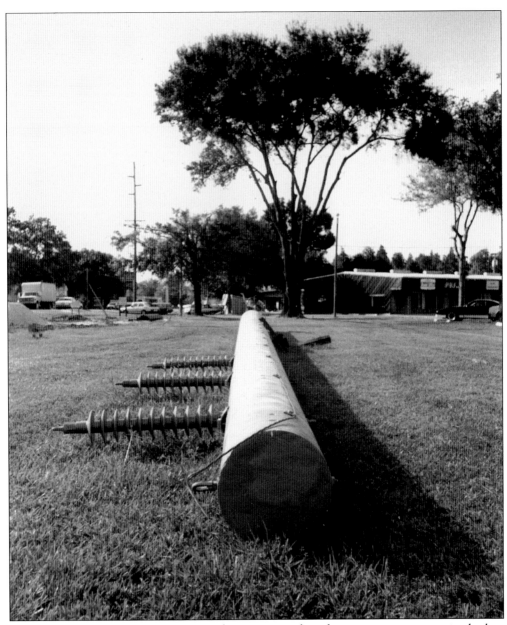

Northwest Hillsborough County was undergoing several road construction projects in the late 1980s, much to the annoyance of motorists who had to snake through seemingly endless miles of orange and white construction barricades. Before roads could be widened, much of the related infrastructure had to be improved or reconfigured to accommodate the wider roadways. In this 1987 photograph, an 80-foot-long concrete power pole reposes off the shoulder of Gunn Highway just north of Linebaugh Avenue. This large power pole, which was erected in front of Dibbs Plaza and remains there today, is just one of dozens that had to be set into the ground while road crews expanded Gunn Highway from two lanes to four. By the end of the decade, the Gunn Highway road-widening project seen in this photograph would be finished in time to accept the thousands of additional commuters that were finding new homes in the western reaches of Carrollwood and Citrus Park in the 1990s. (Courtesy of the author.)

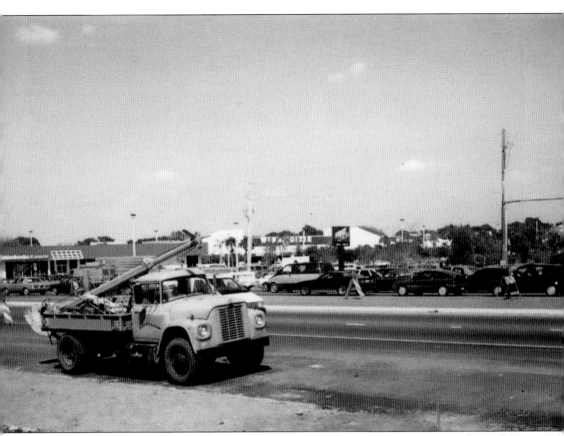

This 1989 photograph shows North Dale Mabry Highway during its transition into the six-lane road it has become today. Taken just to the south of the thoroughfare's busy intersection with West Fletcher Avenue and looking northeast, this view shows some of the businesses that used to call Carrollwood home, including First Union Bank, Waldenbooks & More, and Winn-Dixie. The large truck parked on the road's shoulder in the foreground of this image bears a large auger that was drilling holes in the ground for new utility poles that would be installed during the road widening. At this same time, a major road-widening project was wrapping up along West Fletcher Avenue between Armenia Avenue and North Florida Avenue. It goes without saying that any road travel throughout this area in the late 1980s would have felt more like a headache than a leisurely experience behind the wheel, thanks to the obstacle courses of construction barricades and cones that proliferated along many northwest Hillsborough County streets. (Courtesy of the author.)

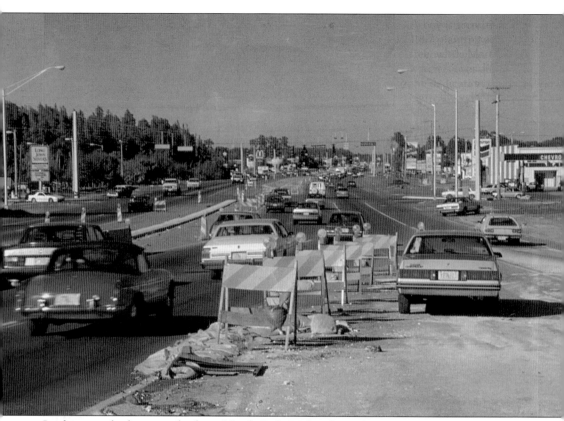

In this view looking north along North Dale Mabry from the overpass at Busch Boulevard, the highway corridor is starting to resemble what Carrollwood motorists see today. This 1989 photograph shows the North Dale Mabry Highway road widening entering its last phases, as newly completed lanes remain barricaded from existing lanes, and new traffic signals replace older ones; the overpass itself also underwent reconfiguration during the project. While many of the businesses in this photograph, such as Eckerd Pharmacy, Chevron, Long John Silver's, and Texaco, have long since closed, the McDonald's in the center background was rebuilt and still serves hungry Carrollwoodians and Carrollwood Center was renovated and remains one of the prime shopping hubs of Original Carrollwood. Note the absence of cellular telephone towers, many of which rise high along the North Dale Mabry corridor today. (Courtesy of Hillsborough County Planning Commission.)

Six

JUST BEYOND LAKE CARROLL

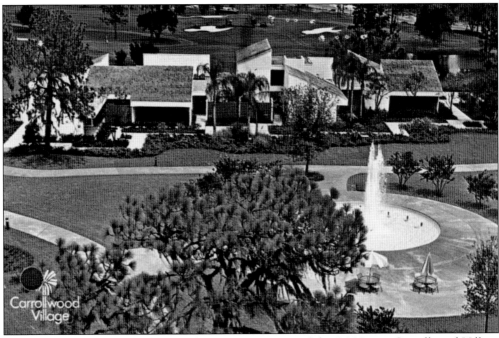

Matt Jetton's Sunstate Builders Inc. began construction of the 2,000-acre Carrollwood Village golf course community in the early 1970s, creating an innovative subdivision featuring not only country club amenities but also a mix of housing styles, including condominiums, townhouses, and an array of single-family homes. Note the golf course fairways, residences, picnicking areas, and scenic walkways beautifully integrated with each other and making for a dynamic community. (Courtesy of Florida State Archives.)

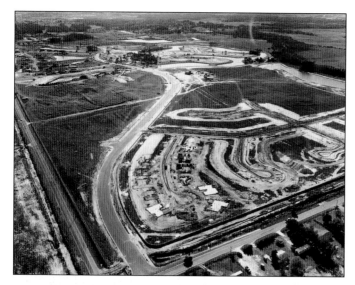

This 1978 photograph shows construction of Carrollwood Village's Phase II development underway. The winding road running from the bottom center of the image up through the middle is South Village Drive, which would soon replace the straight stretch of Casey Road seen at the left. Ehrlich Road, which was two lanes wide at the time this photograph was taken, is seen near the bottom, with single-family homes alongside. (Courtesy of the *Tampa Tribune*.)

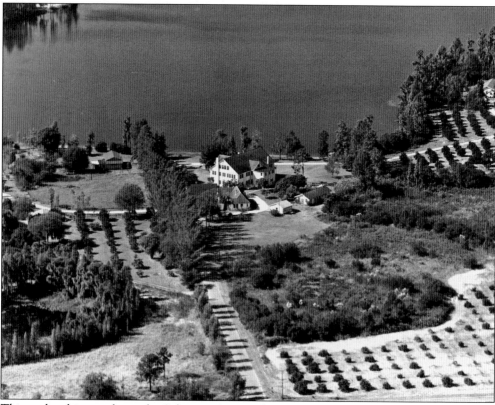

This undated image shows the Salvation Army's three-story, Colonial-style home and hospital just off the eastern shoreline of Lake Ellen. The Salvation Army home on Lake Ellen Lane served the community for many decades, and the tranquil 12.6-acre site eventually became the Florida headquarters. The state's headquarters moved to a much larger facility just off Van Dyke Road in 2004. (Courtesy of the Salvation Army Southern Historical Center, Evangeline Booth College, Object Number 2000.0051.11.)

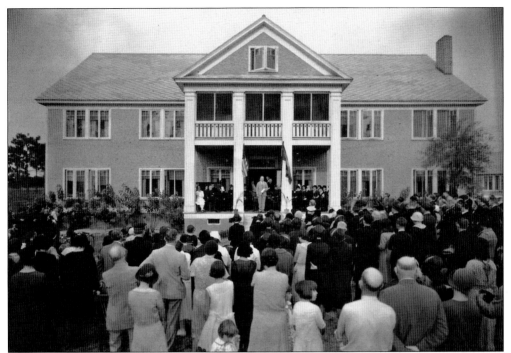

On November 16, 1931, the Salvation Army home and hospital opened for service near Lake Ellen, which is situated just outside this photograph on the left. This facility originally housed unwed mothers, but by the early 1980s would become a nerve center for the Salvation Army upon its Florida headquarters moving to the site. (Courtesy of Tampa-Hillsborough County Public Library.)

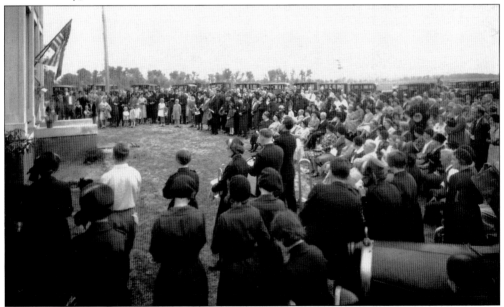

The Salvation Army's home and hospital is pictured during its dedication on November 16, 1931. Note the lack of residential development in this view, which looks southeast toward the vicinity of Lake Carroll's northern shore. (Courtesy of Tampa-Hillsborough County Public Library.)

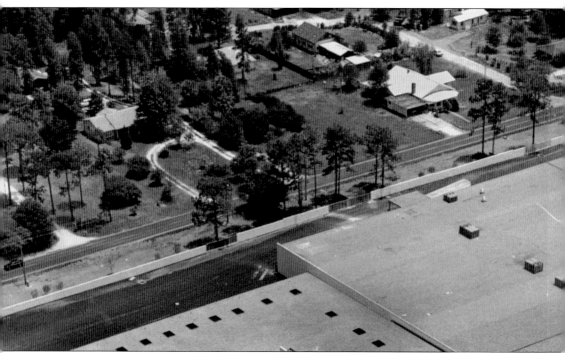

Lake Ellen Beach Park, a small community that consisted of nine homes, was a tiny enclave that in later years became obscured behind Mission Bell Square. While the community may have looked nondescript to many passersby, it had a storied past. All nine homes were owned by Harry Eckhart, a New York trumpeter who played on cruise ships. After living there in the 1960s, during which time he rented the other homes to University of South Florida students, he sold most of the property in 1976. The large home on the right of this photograph was a log cabin that was built in the 1920s and burned to the ground in 2003 during a renovation project. The home was rumored to have been where Al Capone once stayed, hiding money and cocaine in the walls according to one long-running legend. Another account of the neighborhood suggests it was once a nudist colony. What can be verified is that it had one of the county's first homeowners' associations. (Courtesy of the *Tampa Tribune*.)

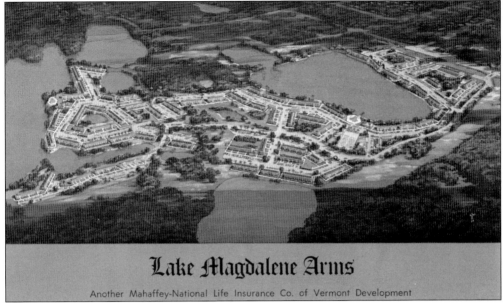

Lake Magdalene Arms

Another Mahaffey-National Life Insurance Co. of Vermont Development

This 1981 postcard shows an artist's rendering of Lake Magdalene Arms, at 2727 West Fletcher Avenue. The development of multiple two-story, redbrick apartment buildings was constructed in 1975 and is located on the southern shore of Lake Magdalene. The community has gone through a few names changes over the years and is currently called the Park at Lake Magdalene. (Courtesy of the author.)

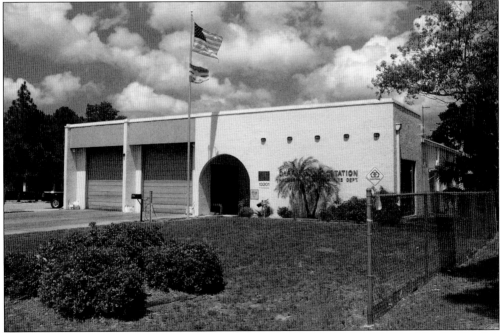

In July 1977, the Armdale Fire Association dedicated Carrollwood Fire Station No. 19. The fire station, located at 13201 North Dale Mabry Highway, is situated across from the Village Center and became a particularly essential facility as Carrollwood Village and the subdivisions around Lake Magdalene were taking shape. (Courtesy of the author.)

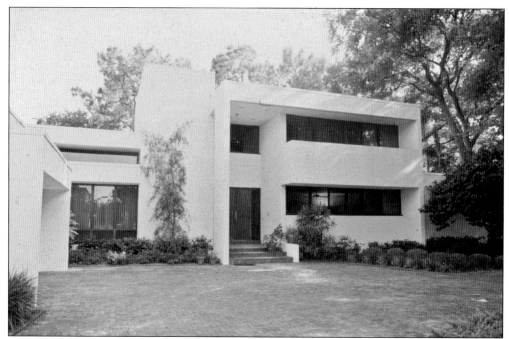

This house, built in 1980, is located on Lake Cove Lane. This White Trout Lake home is a prime example of the contemporary executive homes that have been built on the shores of many lakes throughout the Carrollwood area. (Courtesy of USF Tampa Library Special & Digital Collections.)

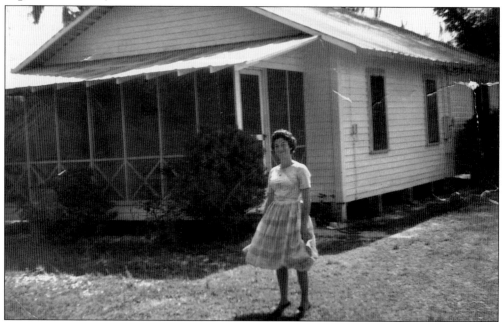

This is the former home of Connie and Hanly Stall (son of Berton and Clara Stall). Built in 1926, the house was located at 12614 Orange Grove Drive. Pictured is Mary Scarborough, who, with her husband, Wayne, purchased the home from the Stalls in 1963, the year this photograph was taken. (Courtesy of the Scarborough family.)

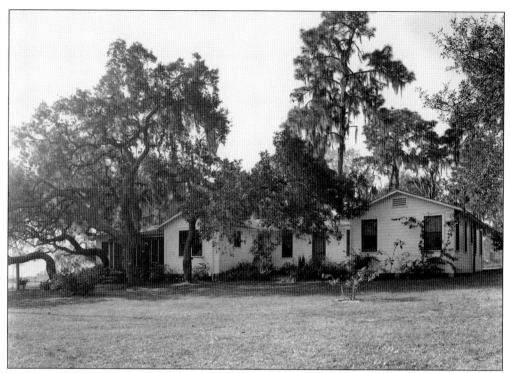

This 1941 home is located on Noreast Lake in the Forest Hills neighborhood a few blocks south of the Hamner Fire Tower. Pictured on January 27, 1949, Noreast Lake, like many of the other lakes in the area, was largely undeveloped at the time, and life for the few people who did live along the lakeshores in the area was absolutely peaceful and physically well distant from the stressors of city life. The topography and fauna surrounding Noreast Lake is much like that of other lakes in the Greater Carrollwood area, with cypress, pine, and oak trees gracefully standing before rolling shorelines. (Both, courtesy of Tampa-Hillsborough County Public Library.)

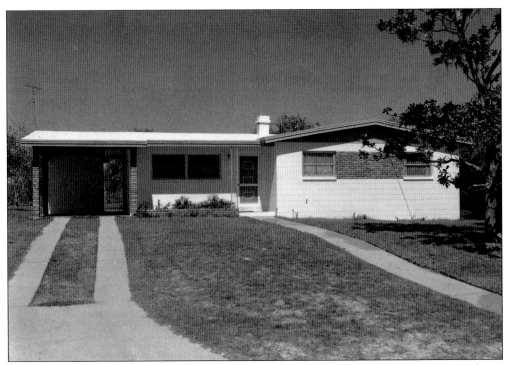

These 1950s tract homes are typical examples of the development occurring just a stone's throw east of Lake Carroll a few years before Matt Jetton began developing the other sides of the lake. Many of the homes in the Forest Hills neighborhood are situated along the fairways of what is now Babe Zaharias Golf Course and feature beautiful, natural vistas that may make some residents forget they are living inside the city limits of Tampa. Much of the Forest Hills community around the golf course was built out during the 1950s, though to this day, there are some scarce, vacant areas of land left in the neighborhoods a few blocks northeast of Lake Carroll. (Both, courtesy of Tampa-Hillsborough County Public Library.)

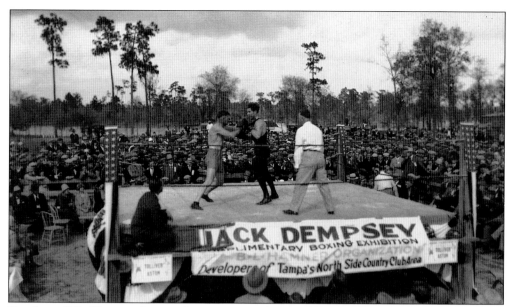

Developer B.L. Hamner drummed up interest in his new Forest Hills community by holding a boxing match that featured none other than world heavyweight champion Jack Dempsey on February 4, 1926. Spectators came from all around, many even climbing trees so they could watch the action from above the throngs of onlookers. (Courtesy of Tampa-Hillsborough County Public Library.)

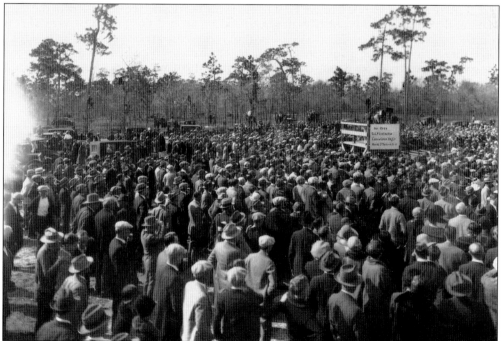

Thousands crowd around the ring on February 4, 1926, as Jack Dempsey makes his appearance at B.L. Hamner's free event promoting his development, North Side Country Club Area. The Forest Hills Golf and Country Club would open nearby that same year. (Courtesy of Tampa-Hillsborough County Public Library.)

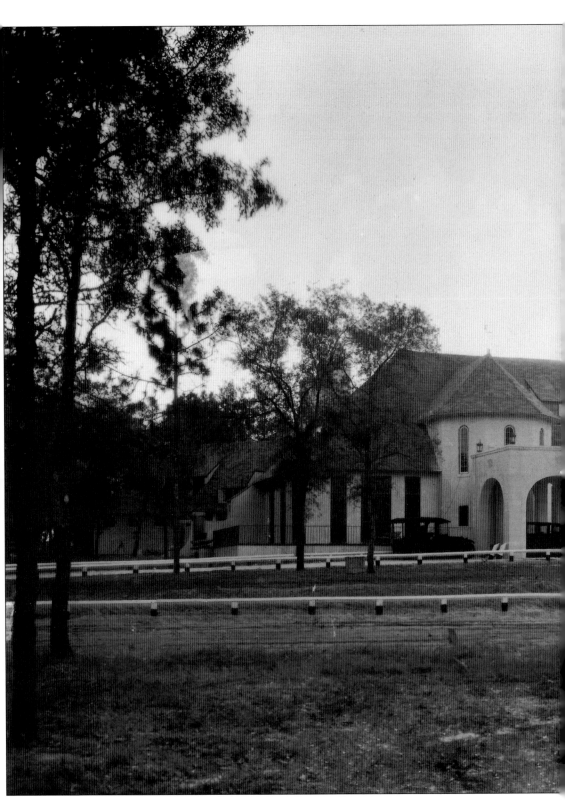

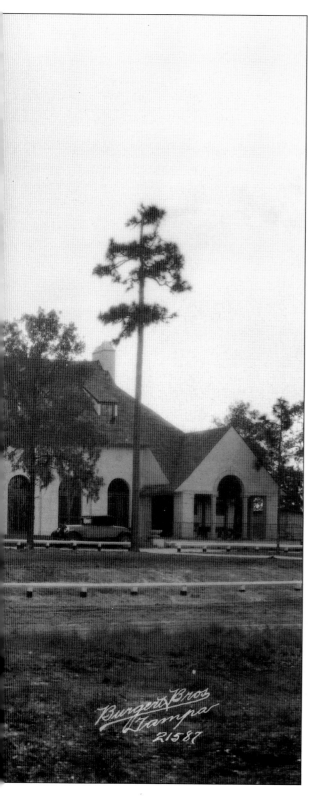

When the Forest Hills Golf and Country Club opened in 1926, it was one of the finest country clubs in Florida. As one of the most elite golf and country clubs in the area, it was where many of Tampa's socialites would spend time hitting the links and mingling with the city's high rollers. The country club included a ballroom and, on the facility's southern end, riding stables. The property would be a major draw for years and, in 1949, was purchased by golfing great Mildred Ella "Babe" Didrikson Zaharias. There, she hosted clinics and exhibitions and was said to have spent much of her time playing rounds on the golf course either on her own or with the Men's Club. After her death in 1956, the course closed. The clubhouse would later fall into disrepair, and the course became overgrown. The formerly grand clubhouse became a hangout for derelicts and burned to the ground in 1962. In the mid-1960s, a developer expressed interest in buying the land for a development. The City of Tampa would step in and, in 1974, reopen the newly revamped golf course as well as build a new clubhouse, naming the facility in honor of Zaharias. Today, the 6,244-yard golf course is managed by the Tampa Sports Authority. (Courtesy of Tampa-Hillsborough County Public Library.)

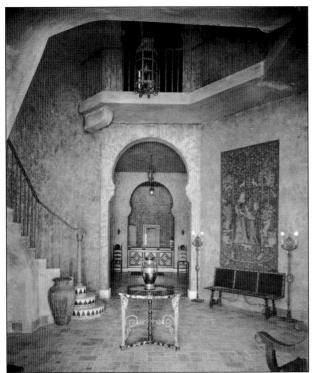

The front hallway of the Forest Hills Golf and Country Club is pictured November 24, 1926. Note the Spanish Revival décor, truly fitting for a Tampa-area clubhouse that was built in a time when the area was still mostly recognized for its association with the Cuban cigars that were manufactured in Ybor City, also known as the "Cigar Capital of the World." (Courtesy of Tampa-Hillsborough County Public Library.)

The clubhouse's grand lounge is pictured on November 22, 1926. Vistas of the fairways and the pine-covered grounds could be seen from the lounge's large windows, creating the perfect venue for a gala ball and other social events. (Courtesy of Tampa-Hillsborough County Public Library.)

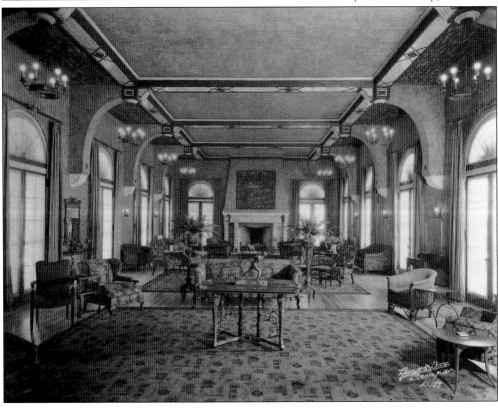

This Christmas party, held December 12, 1931, exemplifies the type of balls that would take place at the two-story Forest Hills Golf and Country Club. When attending a large social event like this one at the clubhouse, a person would have been sure to rub at least a couple of notable elbows by the time the party was over. (Courtesy of Tampa-Hillsborough County Public Library.)

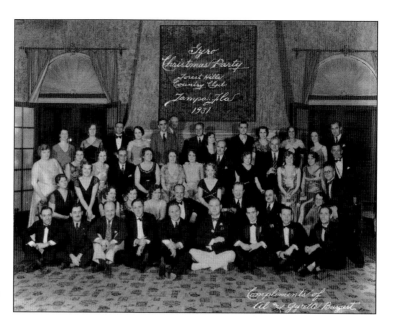

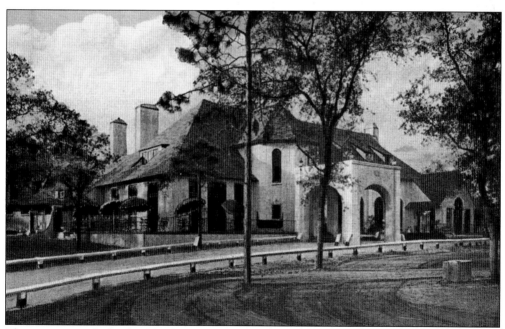

The caption on the back of this late-1920s postcard just about sums up the Forest Hills Golf and Country Club and its course: "One of the state's finest and sportiest golf courses." While the clubhouse is now long gone, the legacy it left behind would raise the bar for the country clubs that would later be built in other areas of Tampa. (Courtesy of the author.)

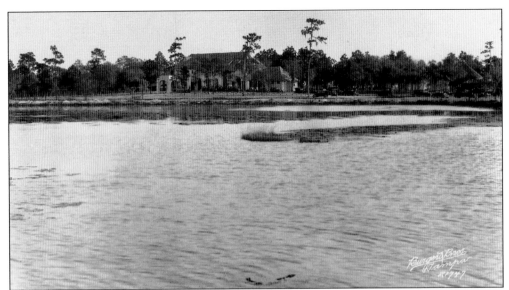

The Forest Hills Golf and Country Club, pictured on November 22, 1926, features only one of the many beautiful lakes that satellite around Lake Carroll, which is just a few blocks to the west of where this photograph was taken. With countless pockets of serenity in Forest Hills and other neighborhoods in the vicinity of Lake Carroll, it is little wonder that people still "take to the hills," as B.L. Hamner sloganized. (Courtesy of Tampa-Hillsborough County Public Library.)

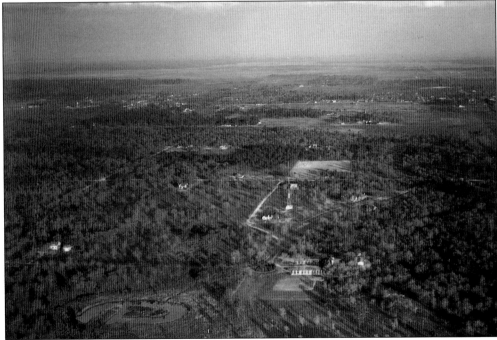

In this view looking east from high above Lake Carroll, the Forest Hills radio transmitter tower looms above homes near the Forest Hills Golf and Country Club in 1937. This radio tower was built in 1929 and was an area landmark for years. The tower was used by WDAE, Florida's oldest radio station, to bolster its signal in Tampa. (Courtesy of Tampa-Hillsborough County Public Library.)

Seven

CHURCHES, SCHOOLS, AND COMMUNITY SPIRIT

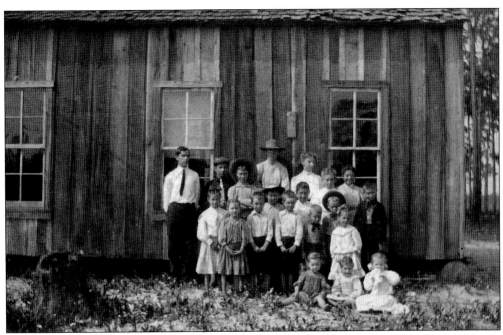

Seen here in this 1907 photograph is Horse-Pond School (later renamed Lake Magdalene School), an early structure that originally stood near the north shore of Lake Carroll. This is one of several schools that would serve children in the areas around Lake Carroll and Lake Magdalene, a community that saw its first school in the 1880s. (Courtesy of the Paul Bearss family.)

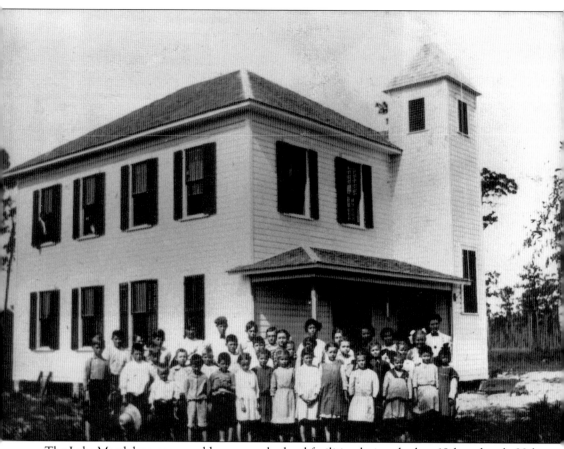

The Lake Magdalene area would see several school facilities during the late 19th and early 20th centuries. The Hazen's School, which was located just northwest of Lake George, and another school, called Pepper Pot (located on the Haypond Slough near where Buchanan Middle School is today), served children in the Lake Magdalene area into the 1900s. In 1906, Hillsborough County built a third school near the north side of Lake Carroll and absorbed students from Hazen's School and Pepper Pot School. The third school was originally called Horse-Pond School, in recognition of Lake Carroll's other name at the time. Around 1907, the Horse-Pond School building would be renamed Lake Magdalene School upon being moved to the corner of Lake Magdalene Boulevard and Smitter Road. This 1921 class photograph shows the structure that would serve as Lake Magdalene School from 1912 to 1926. (Courtesy of the Paul Bearss family.)

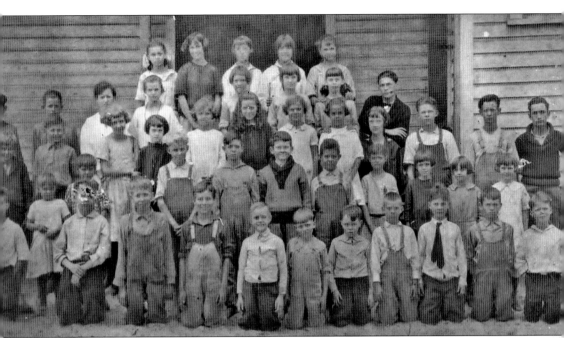

This 1921 photograph shows the entire student body of Lake Magdalene School, which at the time served students in grades one through eight, a common mixture of grades, especially in rural schools of the day. High enrollment at one point necessitated two teachers, one of whom was Esther Bearss, a former student at the school. The growing population around the Lake Magdalene and Lake Carroll areas in the 1920s meant the construction of a new school in 1926, which would be located on the property of the current Lake Magdalene Elementary School on Pine Lake Drive near Rome Avenue. The Lake Magdalene School, built in 1926, was constructed on a concrete slab and featured a cream-colored stucco exterior and a gabled roof as well as an auditorium. In March 1930, a fire swept the school, destroying the structure and everything within. (Courtesy of the Paul Bearss family.)

The current Lake Magdalene Elementary School building was completed in September 1930. Built with fireproof red bricks, the original structure housed the school's classrooms. As the campus has grown over the decades, additional classrooms have been built. Today, the school's redbrick building is where the administration offices are located. (Courtesy of Lake Magdalene Elementary School.)

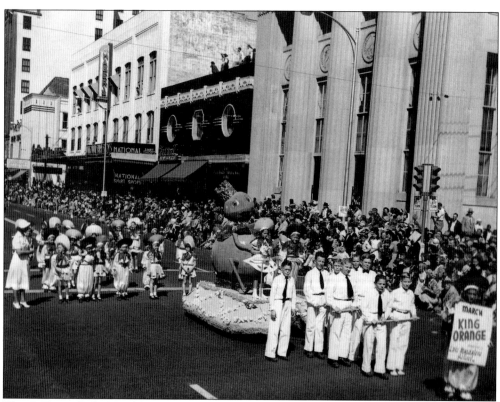

The children of Lake Magdalene Elementary march down North Franklin Street near its intersection with Twiggs Street in the 1951 Children's Gasparilla Parade. Lake Magdalene Elementary has long had a thriving community spirit, boasting a Parent Teacher Association (PTA) that was founded in 1927 and soon became one of the most active PTAs in the nation. (Courtesy of Lake Magdalene Elementary School.)

This Boy Scout Building was located on the grounds of what is now Lake Magdalene United Methodist Church. The structure was dedicated in 1954 and cost $5,000, with most of that amount being donated in both materials and labor. The Boy Scout troop that met here was the only one in Hillsborough County at the time to have its own building. (Courtesy of LMUMC.)

In 1968, Marilyn Gatlin and Betty Anderson opened an innovative school that would afford children an opportunity to explore their unique talents while learning in an educational environment that celebrated their individual gifts. Independent Day School (renamed in 2012 as Corbett Preparatory School of IDS) would hold its first classes at Temple Terrace Presbyterian Church. By 1970, the school outgrew its temporary quarters at the church and moved to its current location at 12015 Orange Grove Drive. (Courtesy of Corbett Preparatory School of IDS.)

This unique-looking geodesic dome structure was built during the 1972–1973 school year and stood as an eye-catching landmark along Orange Grove Drive for many years. During its time, the dome held classrooms, administration offices, and a library. (Courtesy of Corbett Preparatory School of IDS.)

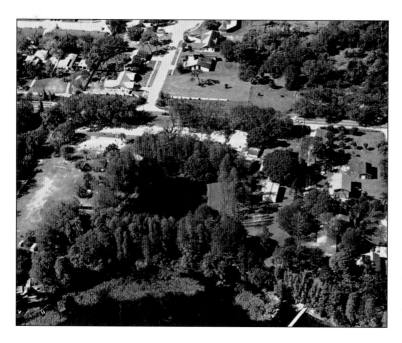

This aerial view of Corbett Preparatory School of IDS in 1986 shows how the property is situated on the western shore of Lake Lipsey (bottom). Crossing the photograph from left to right (above center) is Orange Grove Drive. (Courtesy of Corbett Preparatory School of IDS.)

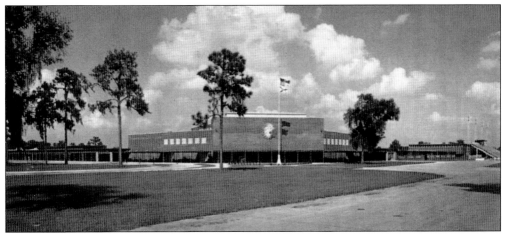

Opening in 1956, Chamberlain High School served as Carrollwood's main high school through the 1970s. As Carrollwood and the rest of northwest Hillsborough County exploded with growth during the 1980s, demands for new schools would prompt the opening of Gaither High School in Northdale in 1984, but many Chamberlain students still hail from Original Carrollwood. (Courtesy of USF Tampa Library Special & Digital Collections.)

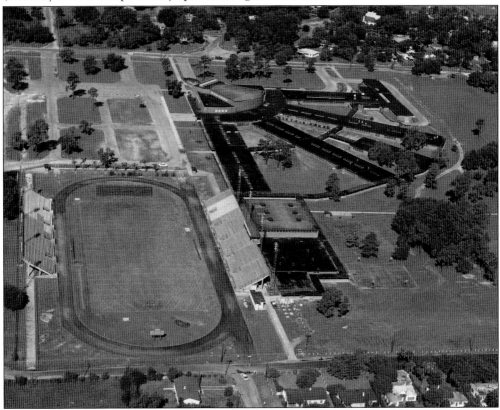

This aerial photograph shows Chamberlain High School's sprawling campus on September 15, 1962, including its football field and its stands during the school's earliest years. North Ola Avenue runs from left to right, below, and North Boulevard traces across the top part of this image. (Courtesy of the Paul Bearss family.)

As Carrollwood grew in the early 1960s, there was a need for a new elementary school. Carrollwood Elementary opened on December 15, 1962, with 12 classrooms. Many of the school's first students were transferred from Twin Lakes Elementary, which was where most Carrollwood children attended elementary grades before 1963. George R. McElvy, AIA, designed the school, which was built at a cost of $368,000. (Courtesy of Carrollwood Elementary School.)

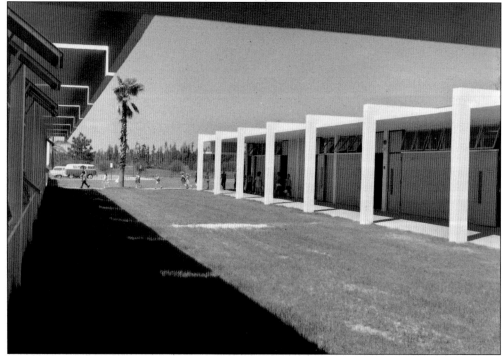

This 1963 image was taken between two classroom buildings at Carrollwood Elementary School before the school's current library was built. In the background, much land remains vacant between North Dale Mabry Highway and the western side of Orange Grove Drive. (Courtesy of Carrollwood Elementary School.)

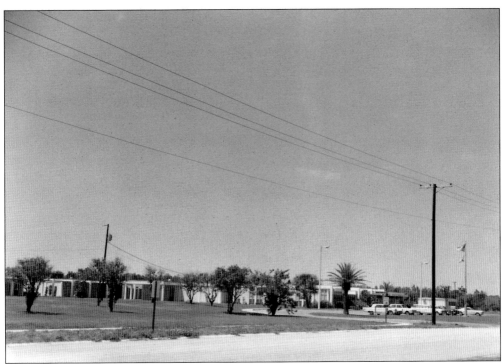

The main entrance of Carrollwood Elementary School can be seen in this photograph, taken from McFarland Road in 1967 before new classrooms were constructed in the early 1970s. (Courtesy of Carrollwood Elementary School.)

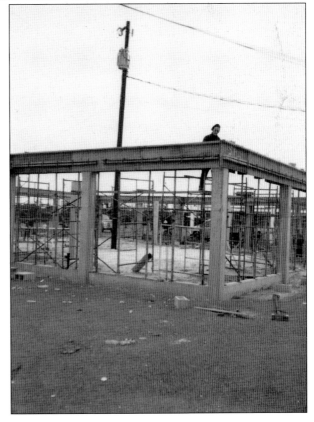

The construction of new classrooms at Carrollwood Elementary School is seen in this 1970 image. The new classrooms would alleviate crowding for a while, but continued population growth throughout the Carrollwood area would require further expansion of the school in the decades that followed. (Courtesy of Carrollwood Elementary School.)

This 1985 concept art depicts Essrig Elementary School, located at 13131 Lynn Turner Road, just west of Carrollwood Village. The school was named for Tampa native Cecile Waterman Essrig, who in 1967 became the first woman to be elected to the Hillsborough County School Board. (Courtesy of Essrig Elementary School.)

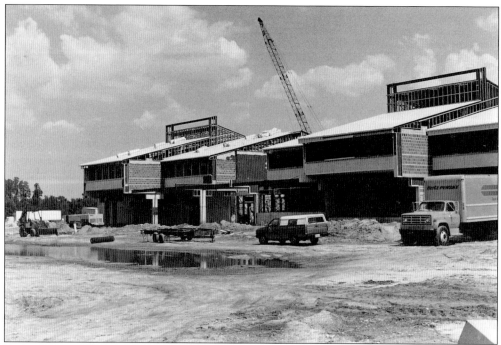

Essrig Elementary School is seen during its construction in 1986. Note the school's two-story layout and contemporary architecture. (Courtesy of Essrig Elementary School.)

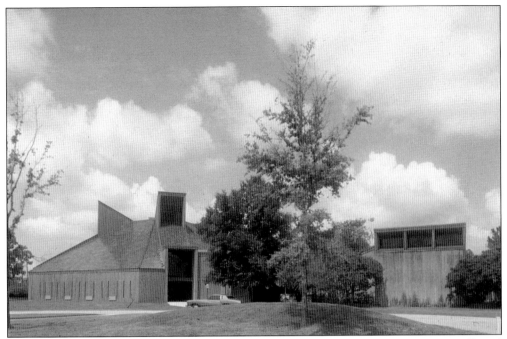

Village Presbyterian Church ranks among the most distinctive landmarks in the Carrollwood area. The church was built in 1985 and is architecturally noted for its striking blue roof and contemporary design. (Courtesy of USF Tampa Library Special & Digital Collections.)

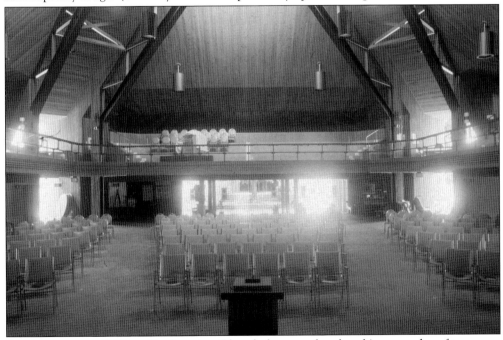

An inside view of Village Presbyterian Church features the church's exposed roof trusses, a choir loft and balcony that is cantilevered on three sides, and an interior that is lit by clearstory windows that reach beyond the roofline of the structure. (Courtesy of USF Tampa Library Special & Digital Collections.)

In September 1963, Fr. Laurence Higgins (now monsignor) began a mission at St. Lawrence Catholic Church that would grow to become the St. Paul Parish. Twelve families attended the first Mass of St. Paul Parish, which was held at Carrollwood Elementary School. In September 1966, Fr. John F. Lima became the church's first pastor, who led the efforts to construct the parish's first church, which was dedicated in June 1970. (Courtesy of St. Paul Catholic Church.)

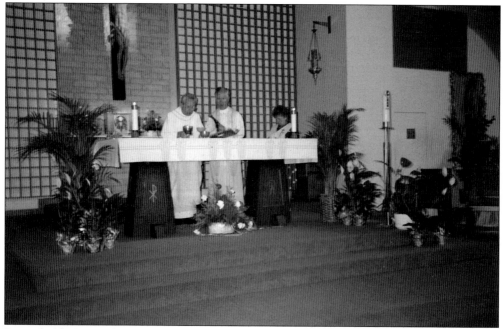

Priests hold Mass in the original St. Paul Catholic Church sanctuary in this 1988 photograph. As the church continued to gain new parishioners throughout the 1980s, an effort went underway to begin the construction of a much larger sanctuary. The sanctuary seen in this image would become the church's family center. (Courtesy of St. Paul Catholic Church.)

In 1989, St. Paul Catholic Church began construction of its current sanctuary, pictured in 1990, soon after the completion of the structure. The new sanctuary would feature contemporary architectural styling, a chapel, and towering stained-glass windows. (Courtesy of St. Paul Catholic Church.)

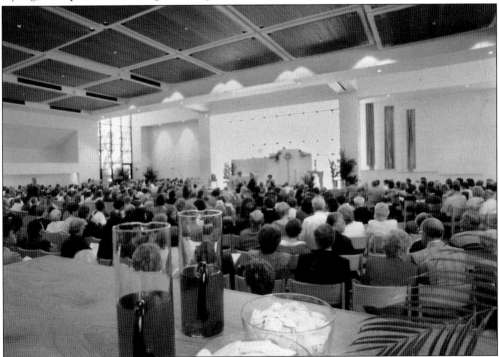

This 1990 photograph shows one of the first Masses to be held at the current sanctuary, which can accommodate 850 parishioners. The structure also has a chapel that can seat 150 people and features a nursery, a choir rehearsal room, and an elevated baptistery with flowing water. (Courtesy of St. Paul Catholic Church.)

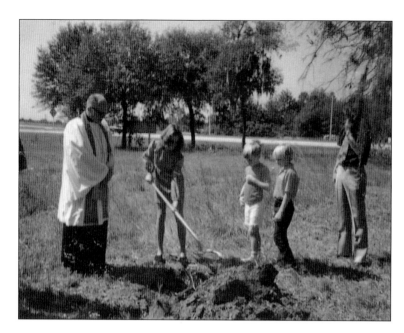

Grace Lutheran first held services at Carrollwood Elementary School in 1970. The church broke ground on its first permanent sanctuary on October 8, 1972. The first service in the new church building was held on Easter Sunday, April 22, 1973. (Courtesy of Grace Lutheran Church.)

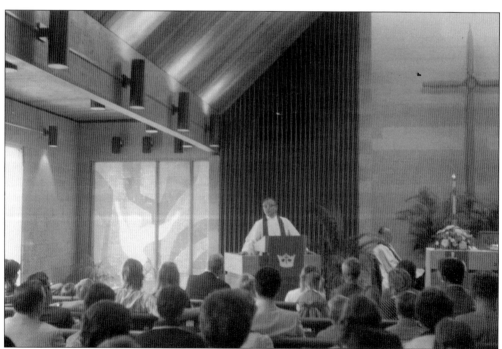

The first sanctuary at Grace Lutheran Church was formally dedicated in a service presided by Bishop Royal Yount on September 30, 1973, a time when the church had 230 members. Note the sanctuary's interior architecture, which features soaring cathedral ceilings and the stained-glass "Dove Window." (Courtesy of Grace Lutheran Church.)

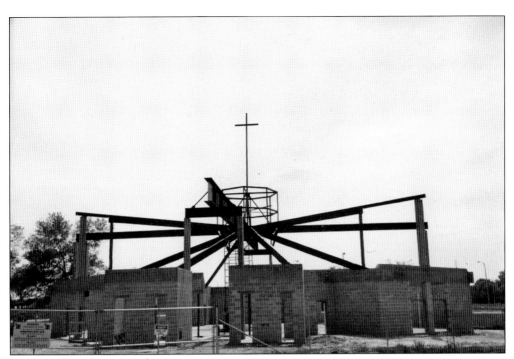

As Carrollwood continued to grow throughout the 1980s, so too did the membership at Grace Lutheran Church. On September 7, 1986, the church broke ground on its larger, current sanctuary, which stands just to the south of the church's first sanctuary. Construction of the new sanctuary is seen in this 1987 photograph. (Courtesy of Grace Lutheran Church.)

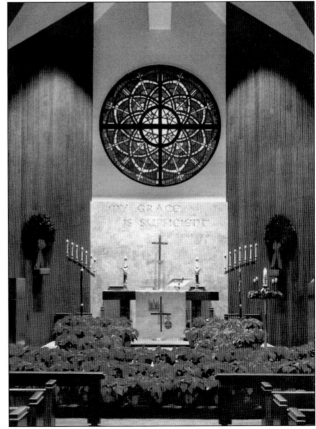

This photograph shows the interior of Grace Lutheran Church's second, current sanctuary as it appeared during a Christmas season in the late 1980s. The sanctuary features stained glass, a unique roof structure consisting of multiple gabled ends, and eight large windows that shower light from above the floor. (Courtesy of Grace Lutheran Church.)

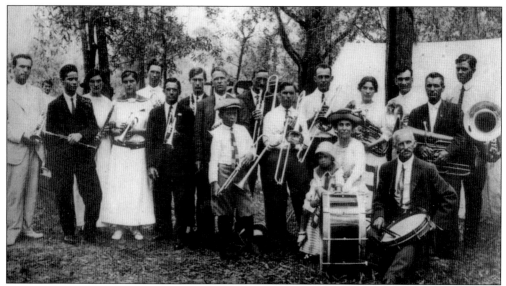

The residents of Lake Magdalene have shown their community pride in various ways over the years. In the early 1900s, Lake Magdalene even had its own band. The community band consisted of around 20 residents and featured drums, clarinets, trombones, and tubas. (Courtesy of the Harold Bearss family.)

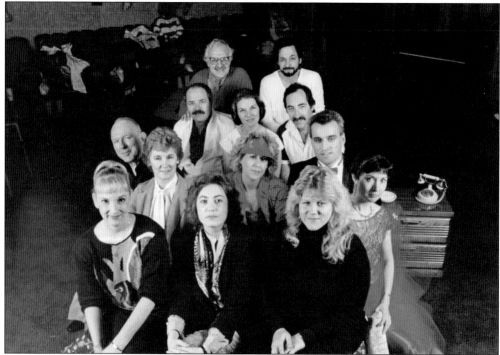

Seen here is the cast of *California Suite*, one of the headlining plays performed at the Carrollwood Players Theater during its 1987–1988 season. The Carrollwood Players community theater company was established in 1981 and has allowed many local residents to enjoy a moment in the spotlight. The staff consists of talented, dedicated volunteers, many of whom have served the theater for several years. (Courtesy of Carrollwood Players Theater.)

Eight

WHERE THE ACTION IS

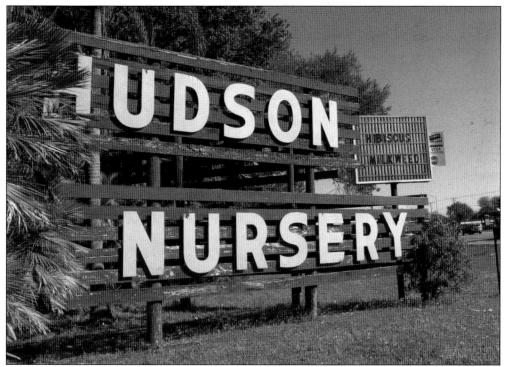

In the mid-1950s, one of the few establishments along Dale Mabry Highway north of Hillsborough Avenue was Hudson Nursery. Opened in 1955, Hudson Nursery had 10 acres of tropical and exotic plants as well as many native and more common cultivars. The Hudson family closed the Dale Mabry nursery in 2004, but continues to sell a plethora of trees, flowering plants, and other landscape foliage in Lutz. (Courtesy of the *Tampa Tribune*.)

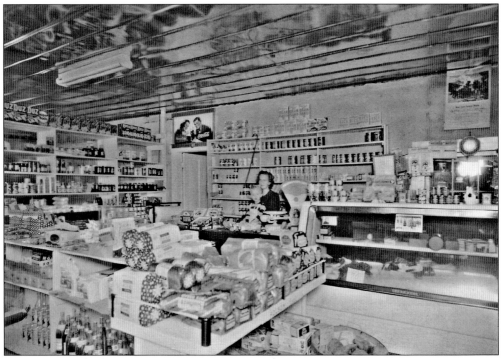

The Bearss Grocery, located at 13313 North Florida Avenue, was where many residents in Forest Hills, Lake Magdalene, and surrounding neighborhoods would buy their milk, bread, eggs, produce, deli meat, and other essentials. (Courtesy of the Harold Bearss family.)

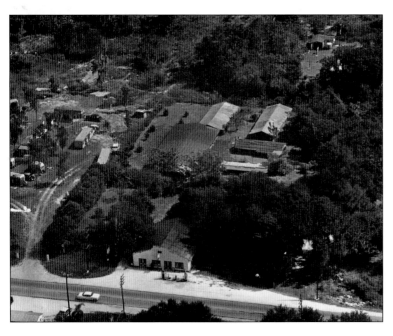

This 1950s aerial photograph shows Bearss Grocery. A two-lane Florida Avenue is seen running along the bottom of this photograph, with sparse development surrounding the property. Today, this site is occupied by a major car dealership that sits at the southeast corner of North Florida Avenue and East Fletcher Avenue. (Courtesy of the Harold Bearss family.)

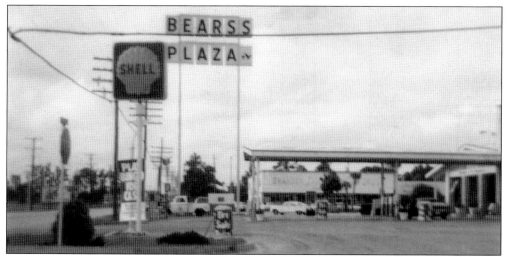

Bearss Plaza was built at the southwest corner of North Florida and West Bearss Avenues in 1965. Featuring a grocery store and several smaller stores, Bearss Plaza was a major retail hub in Lake Magdalene at a time when there were few other places to shop in the area. (Courtesy of the Harold Bearss family.)

Bearss Groves produce stand has been in operation for many years at the southwest corner of Bearss Avenue and Lake Magdalene Boulevard. Produce is available year-round, and the market is packed when its sells pumpkins in October and Christmas trees in November and December. A large oak tree that stands on the northern end of the property is thought to be more than 400 years old, making it one of the oldest trees in Hillsborough County. (Courtesy of Bearss Groves.)

Meli's Place Restaurant, located at 13502 North Florida Avenue, can be seen here on February 6, 1954. One could get draft beer in a frosty mug for 15¢, hamburgers, spaghetti, chili, sandwiches, and Coca-Cola, among other delicious offerings. The restaurant even featured a television—not an amenity to yawn at in the mid-1950s. (Courtesy of Tampa-Hillsborough County Public Library.)

Carrollwood State Bank started serving local residents in 1959 and for several years was one of the few financial institutions serving residents in the Carrollwood area. Standing at the northeast corner of North Dale Mabry Highway and Lake Carroll Way, Carrollwood State Bank would eventually change hands and become Barnett Bank in 1981. (Courtesy of USF Tampa Library Special & Digital Collections.)

The interior of the Mary Carter Paint warehouse is pictured on December 16, 1957. Located near the intersection of Gunn Highway and Henderson Road, the facility served as the company's headquarters and would in 1960 feature a research center with the largest privately owned laboratory of its kind in the Southeast. (Courtesy of Tampa-Hillsborough County Public Library.)

The Carrollwood Village Executive Center was one of the first major office complexes in the Carrollwood area when it opened in 1971. As this 1977 advertisement boasts, the office complex's location was perfectly situated for business owners living in the Carrollwood area who wanted to buck the long daily commutes to downtown Tampa and other parts of Hillsborough County more commonly associated with office buildings. (Courtesy of USF Tampa Library Special & Digital Collections.)

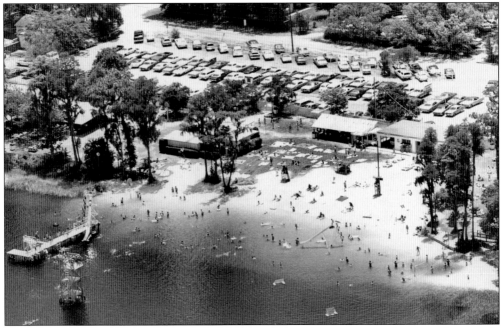

For many years, the serene beauty of Lake Ellen drew weekend vacationers and local residents alike to its shores to enjoy the peace and quiet of the natural surroundings. The number of visitors swelled as neighborhood development surrounded the lake during the 1960s and 1970s. This 1975 aerial of the lake and its facilities located on the south shore, just off Lake Ellen Drive, shows how busy a weekend at Lake Ellen Beach could be. (Courtesy of the *Tampa Tribune*.)

Lake Ellen Beach featured many amenities, and one of them was a multistory dive tower located in the lake, pictured in 1979. The wood-frame tower was especially a hit with teenagers and anyone else who wanted to show the world (or at least other guests at the beach) the best cannonballs. (Courtesy of the *Tampa Tribune*.)

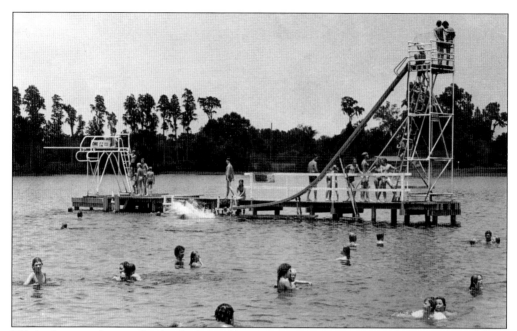

While the most daring of individuals would plunge off the dive tower, those who wanted a little thrill without making (as big) a splash could shoot down this slide on the lake. Note the shoreline across from the beach was still largely undeveloped as of 1979. (Courtesy of the *Tampa Tribune*.)

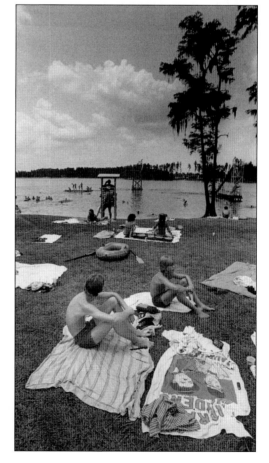

Lake Ellen Beach was perfect for those who wanted to refresh themselves in Lake Ellen's clean water, but this weekend hot spot was also a popular place to enjoy a picnic or simply lie on the grass and soak in the sun, as seen in 1979. In the distance are the wooden dive tower in the middle of the lake and stands of cypress on the opposite shore. (Courtesy of the *Tampa Tribune*.)

If Dale Mabry is the most ubiquitous name in Carrollwood, then Publix is perhaps the second most so. Publix has long been a major presence in the Carrollwood community, with roughly a half dozen stores directly serving the area. The first location to open in Carrollwood was at 10015 North Dale Mabry Highway in the Carrollwood Center shopping mall. The store can be seen here on opening day on October 1, 1970. (Courtesy of Publix.)

As the community spread northward and westward, Publix's presence in the Carrollwood area did, too. On September 30, 1980, Publix opened its second Carrollwood store at 13178 North Dale Mabry Highway at the Village Center. This photograph was taken on grand opening day and showcases the complex's original facade, which was clad in dark wood shingles. (Courtesy of Publix.)

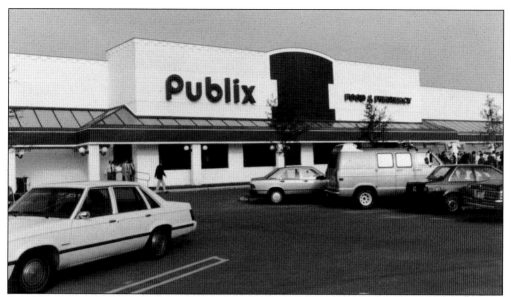

On November 6, 1986, Publix opened another Carrollwood-area store, this one primarily serving residents who were living in the subdivisions that were being developed along the Gunn Highway corridor in the areas of Anderson and Henderson roads. This photograph shows the store's grand opening day at its 12026 Anderson Road location in Westgate Shopping Center. (Courtesy of Publix.)

Payne's Pharmacy was located at 901 West Linebaugh Avenue. The view in this 1960 photograph, looking west down Linebaugh Avenue, shows the pharmacy's sign, which features a vintage neon mortar and pestle. Family-owned businesses such as Payne's Pharmacy thrived at a time when the Carrollwood area and the surrounding reaches of northwest Hillsborough County were still largely rural and devoid of major corporate chain establishments. (Courtesy of the Cinchett Collection.)

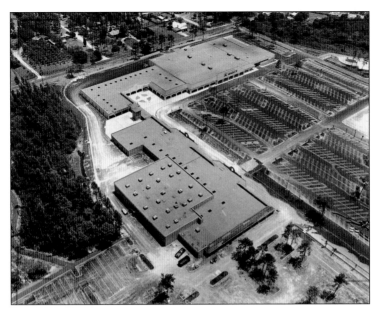

As development crept farther north toward modern-day Fletcher and Bearss Avenues, so too did shoppers. Seen under construction in May 1981 is Mission Bell Square, which would open in the summer of that year at the northeast corner of North Dale Mabry Highway and Stall Road. The shopping center was anchored by Kmart (upper right) and The Movies at Mission Bell Square (lower left). (Courtesy of the *Tampa Tribune*.)

In May 1981, construction crews can be seen wrapping up work on The Movies at Mission Bell Square. Featuring 3,000 seats and a sound system that was ahead of its time, The Movies at Mission Bell would become the first cinema complex to open anywhere in the Carrollwood area. (Courtesy of the *Tampa Tribune*.)

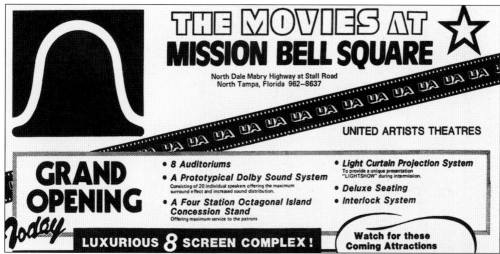

June 26, 1981, was opening day for The Movies at Mission Bell Square. The first films to play at the state-of-the-art theater included *For Your Eyes Only* (of the long-running James Bond series), *Swiss Family Robinson*, *Ordinary People*, *The Great Muppet Caper*, and on two screens each *Stripes* and *Raiders of the Lost Ark*. (Courtesy of the *Tampa Tribune*.)

With eight screens of cinema magic on one end of the shopping center and a plethora of restaurants, shops, and watering holes throughout the rest of the complex, Mission Bell Square was hopping during Friday and Saturday nights in the 1980s. This 1983 photograph, taken at the shopping center, shows what would have been a typical, busy scene there during weekend evenings. (Courtesy of the *Tampa Tribune*.)

Opened in 1980, the Village Center is one of the most popular shopping destinations in the Carrollwood area. Located at the northwest corner of the North Dale Mabry Highway and West Fletcher Avenue intersection, the Village Center has undergone several renovations over the years but has many longtime anchors, including Publix, Walgreens, and Stein Mart. (Courtesy of Publix.)

Built in 1985, Grand Plaza is a retail hub that also features a major office center on the eastern side of its property. Since its opening, the complex has featured several notable restaurants, stores, and other businesses. This view looks toward the center's eastern parking lot and the office park on October 12, 1989. (Courtesy of Hillsborough County Planning Commission.)

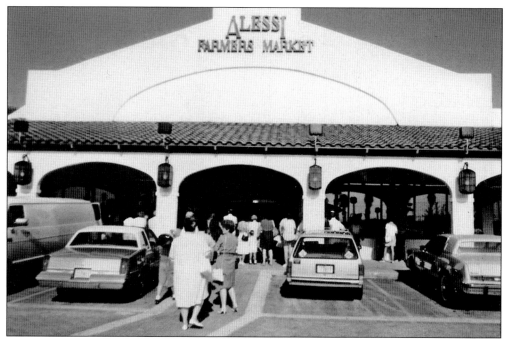

In July 1987, a new epicurean concept entered the Carrollwood area, and that came in the form of Alessi Farmer's Market. Offering a combination of upscale food, gourmet entertainment, and homespun produce and deli items, Alessi Farmer's Market took cues from many of the world's best food marketplaces and refined them into a unique, multisensory experience. The store was located at 4802 Gunn Highway in the Town Centre shopping plaza. (Courtesy of Gary Wishnatzki.)

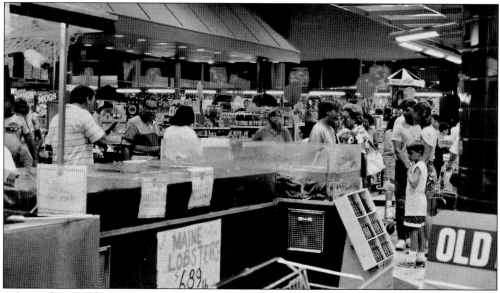

Where else could someone find Maine lobsters, Cuban sandwiches, homemade liverwurst, watermelons, fudge, chardonnay, and freshly produced honey in one place? The indulgent combination of gourmet offerings, entertaining presentations, and fresh seafood and produce selections meant busy weekends at the Alessi Farmer's Market, as seen in 1987. (Courtesy of Gary Wishnatzki.)

The Carrollwood branch of the United States Post Office, located at 12651 North Dale Mabry Highway, began serving local residents in 1977. Its primary service area is the prestigious 33618 Carrollwood zip code, but this branch sees plenty of foot traffic from customers living in other zip codes who enjoy the convenience of handling mail errands within only a short drive of the surrounding restaurants and stores. (Courtesy of the author.)

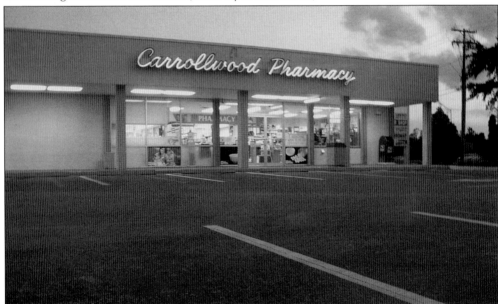

Founded in 1965, the Carrollwood Pharmacy was a fixture at Carrollwood Center for most of the business's existence. When the Carrollwood Pharmacy was located along Lake Carroll Way at Carrollwood Center, its storefront was situated in one of the area's first strip malls. The pharmacy distinguishes itself from the chains by providing custom compounded drugs and a variety of health care equipment. (Courtesy of Dan Fucarino.)

This 1966 photograph shows Orange Pharmacy, located at 2318 West Linebaugh Avenue. With a name that played off the prominence of the surrounding citrus groves, this drugstore was conveniently located only a stone's throw southeast of Lake Carroll. While Orange Pharmacy is now gone, the building in which it was located is still standing today. (Courtesy of the Cinchett Collection.)

From date nights to Sunday family lunches, the Wildwood Restaurant, which opened in 1986 and closed in the mid-1990s, was a favorite place to dine for many Carrollwood residents. As this Wildwood Restaurant advertisement shows, menu options consisted of steak and barbecued foods (the establishment also served seafood), and prices were targeted to the mid-scale diner. (Courtesy of USF Tampa Library Special & Digital Collections.)

DISCOVER THOUSANDS OF LOCAL HISTORY BOOKS FEATURING MILLIONS OF VINTAGE IMAGES

Arcadia Publishing, the leading local history publisher in the United States, is committed to making history accessible and meaningful through publishing books that celebrate and preserve the heritage of America's people and places.

Find more books like this at
www.arcadiapublishing.com

Search for your hometown history, your old stomping grounds, and even your favorite sports team.